BOOKS IN THIS SERIES

- Draw 50 Airplanes, Aircraft, and Spacecraft
- Draw 50 Aliens, UFOs, Galaxy Ghouls, Milky Way Marauders, and Other Extraterrestrial Creatures
- Draw 50 Animal 'Toons
- Draw 50 Animals
- Draw 50 Athletes
- Draw 50 Beasties and Yugglies and Turnover Uglies and Things That Go Bump in the Night
- Draw 50 Birds
- Draw 50 Boats, Ships, Trucks, and Trains
- Draw 50 Buildings and Other Structures
- Draw 50 Cars, Trucks, and Motorcycles
- Draw 50 Cats
- Draw 50 Creepy Crawlies
- Draw 50 Dinosaurs and Other Prehistoric Animals
- Draw 50 Dogs
- Draw 50 Endangered Animals
- **Draw 50 Famous Caricatures**
- Draw 50 Famous Cartoons
- Draw 50 Famous Faces
- Draw 50 Flowers, Trees, and Other Plants
- Draw 50 Holiday Decorations
- Draw 50 Horses
- Draw 50 Monsters, Creeps, Superheroes, Demons, Dragons, Nerds, Dirts, Ghouls, Giants, Vampires, Zombies, and Other Curiosa . . .
- Draw 50 People
- Draw 50 People of the Bible
- Draw 50 Sharks, Whales, and Other Sea Creatures
- Draw 50 Vehicles

Draw 50 Horses

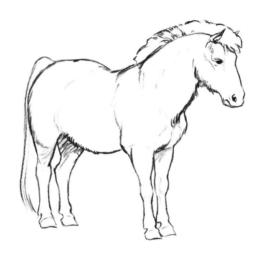

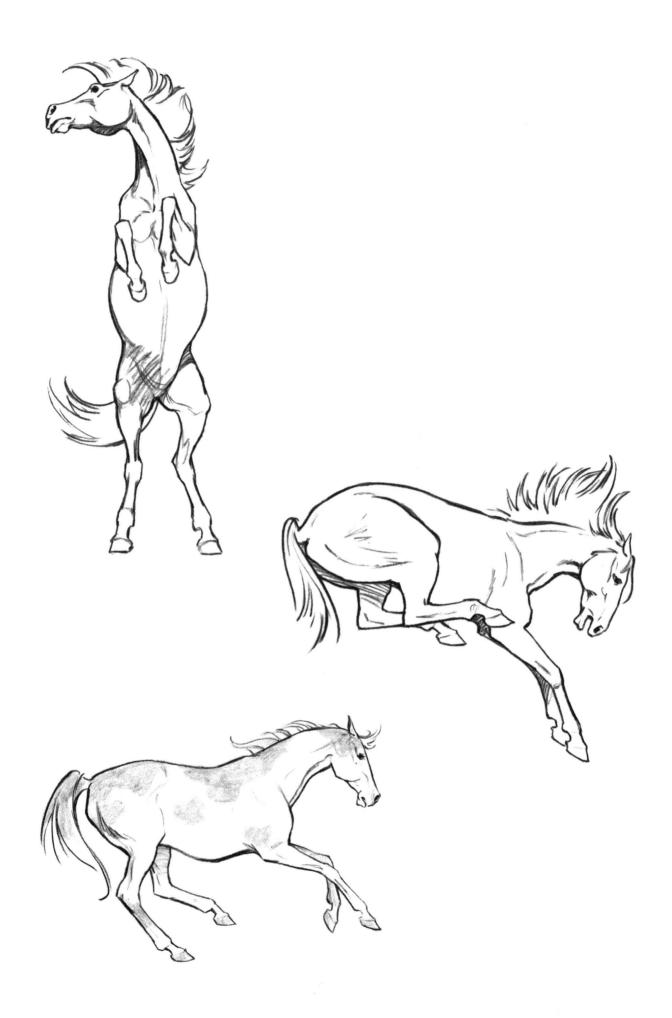

Draw 50 Horses

Lee J. Ames

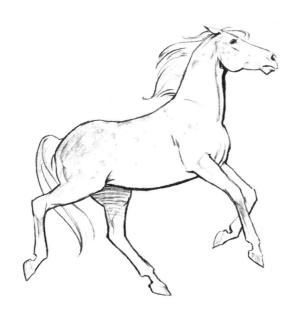

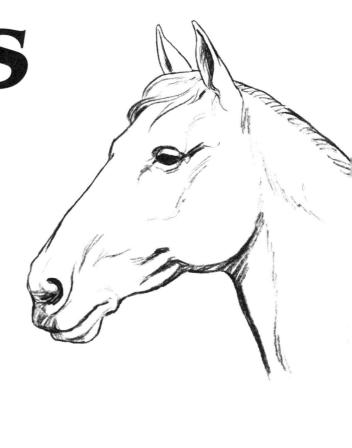

Published by Broadway Books a division of Random House, Inc. 1540 Broadway, New York, New York 10036

Broadway Books and it's logo, a letter B bisected on the diagonal, are trademarks of Broadway Books, a division of Random House, Inc.

ISBN: 0-385-17640-6 Trade

0-385-17641-4 Prebound 0-385-17642-2 Paperback

Text and Illustrations copyright © 1984 by Lee J. Ames and Murray D. Zak

All rights reserved

Printed in the United States of America

Library of Congress Cataloging in Publication Data Ames, Lee J.

Draw 50 horses.

Summary: Step-by-step instructions for drawing different breeds of horses in a variety of poses.

1. Horses in art — Juvenile literature. 2. Drawing — Technique — Juvenile literature. [1. Horses in art. 2. Animal painting and illustration.

3. Drawing — Technique] I. Title. II. Title: Draw fifty horses.

NC783.8.H65A43 1984

743'.69725

81-43646

25 24

To Alison, regal and elegant . . .

. . . and thank you, Tamara Scott, for your help.

To the Reader

Broncos, Arabians, thoroughbreds, dancers and prancers—here they all are. By following simple, step-by-step instructions, you can draw them.

Start by gathering your equipment. You will need paper, medium and/or soft pencils, and a kneaded eraser (available at art supply stores). You might also wish to use India ink, a fine brush or pen, or perhaps a fine pointed felt-tip or ball-point pen.

Next, choose one of the horses...you needn't start with the first illustration. As you begin, remember that the first few steps—the foundation of the drawing—are the most important. If they are not right, the end result will be distorted. So, follow these steps *very carefully* and keep your lines *very* light. In order that they can be clearly seen, these steps are shown darker in this book than you should draw them. You can lighten your lines by gently pressing them with the kneaded eraser.

Make sure step one is accurate before you go on to step two. To check your own accuracy, hold the work up to a mirror after a few steps. By reversing the image, the mirror gives you a new view of the drawing. If you haven't done it quite right, you may notice that your drawing is out of proportion or off to one side.

You can reinforce the drawing by going over the completed final step with India ink and a fine brush or pen; or with the felt-tip or ball-point. When the ink has dried thoroughly, gently remove the pencil lines with the kneaded eraser.

Don't get discouraged if, at first, you find it difficult to duplicate the shapes pictured. Just keep at it, and in no time you'll be able to make the pencil go just where you wish. Drawing, like any other skill, requires patience, practice, and perseverance.

Remember, this book presents only one method of drawing. In a most enjoyable way, it will help you develop a certain skill and control. But there are many other ways of drawing to which you can apply this skill, and the more of them you explore, the more interesting your drawings will be.

Lee J. Ames

To the Parent or Teacher

Drawing, like any other skill, requires practice and discipline. But this does not mean that rewards cannot be found along every step of the way.

While contemporary methods of art instruction rightly emphasize freedom of expression and experimentation, they often lose sight of a very basic, traditional and valuable approach: the "follow me, step by step" way that I learned as a youth.

Just as a beginning musician is given simple, beautiful melodies to play, so too the young artist needs to gain a sense of satisfaction and pride in his/her work as soon as possible. The "do as I do" steps that I have laid out here provide the opportunity to mimic finished images, pictures the young artist is eager to draw.

Mimicry is prerequisite for developing creativity. We learn the use of our tools through mimicry, and once we have those tools we are free to express ourselves in whatever fashion we choose. The use of this book will help lay a solid foundation for the child, one that can be continued with other books in the Draw 50 series, or even used to complement different approaches to drawing.

Above all, the joy of making a credible, attractive image will encourage the child to continue and grow as an artist, giving him even more of a sense of pride and accomplishment when his friends say, "Peter can draw a horse better than anyone else!"

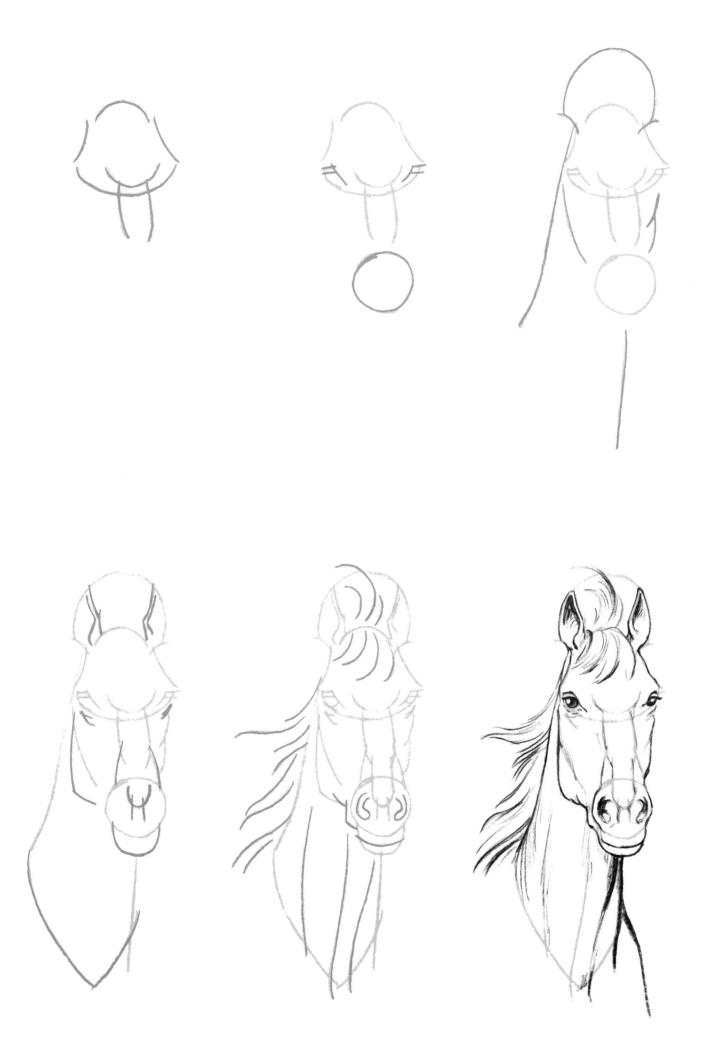

Portrait, frontal view

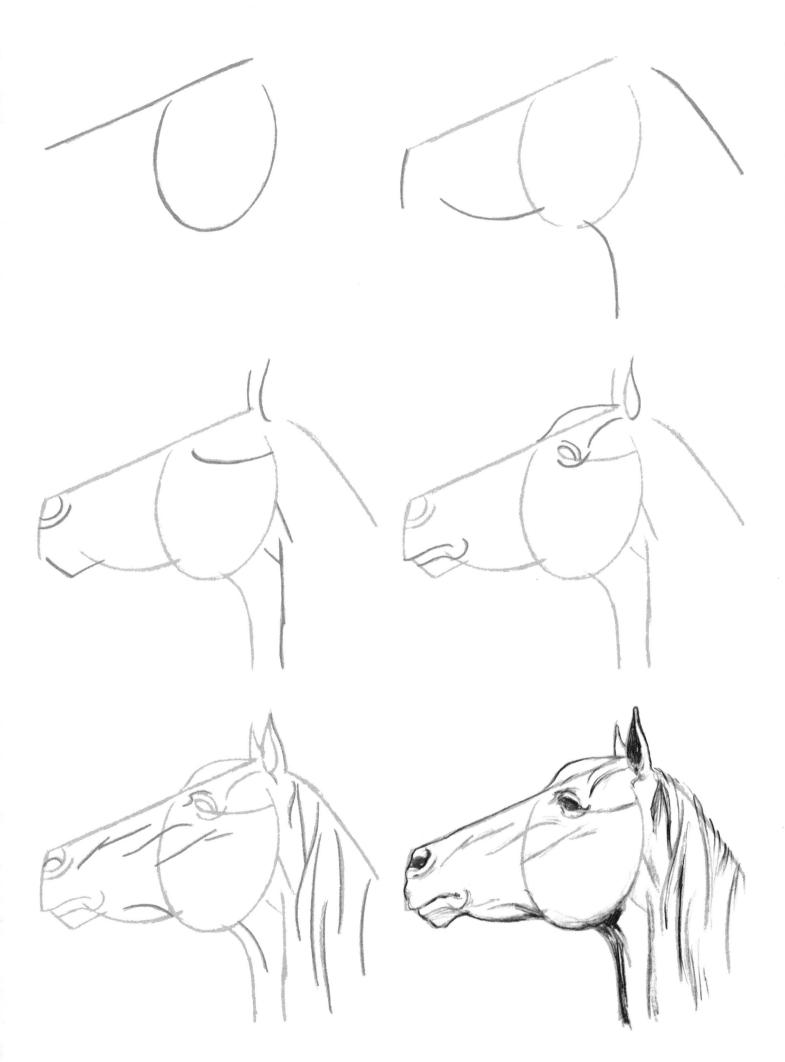

Portrait, side view

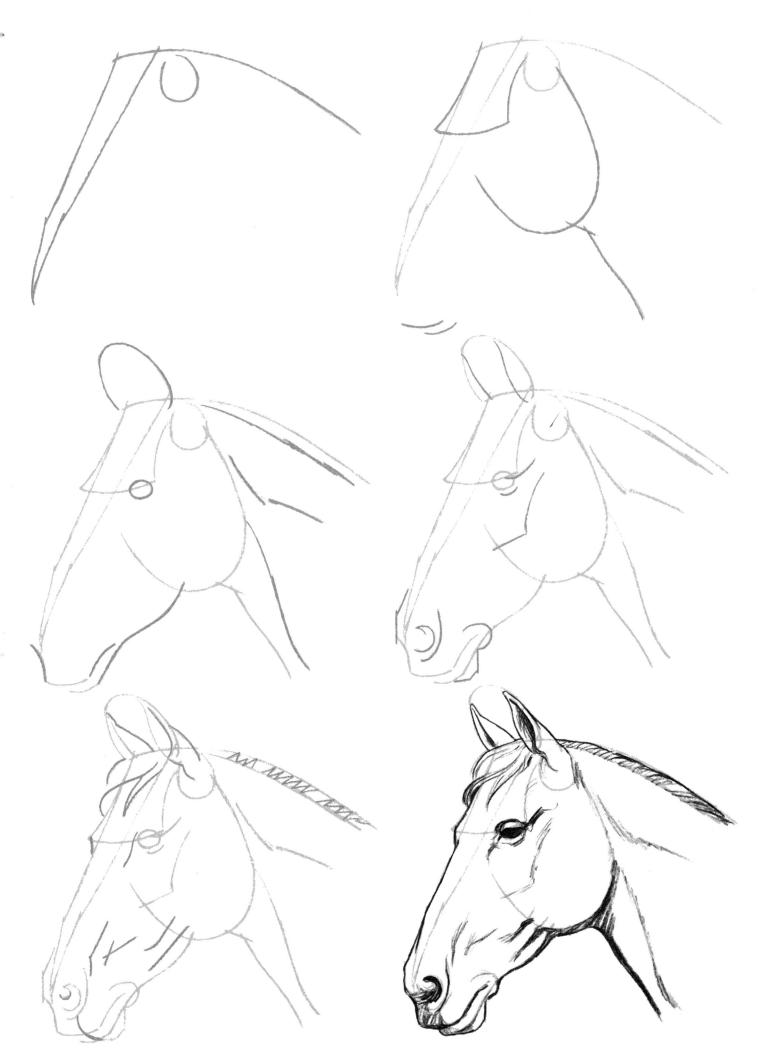

Portrait, side view

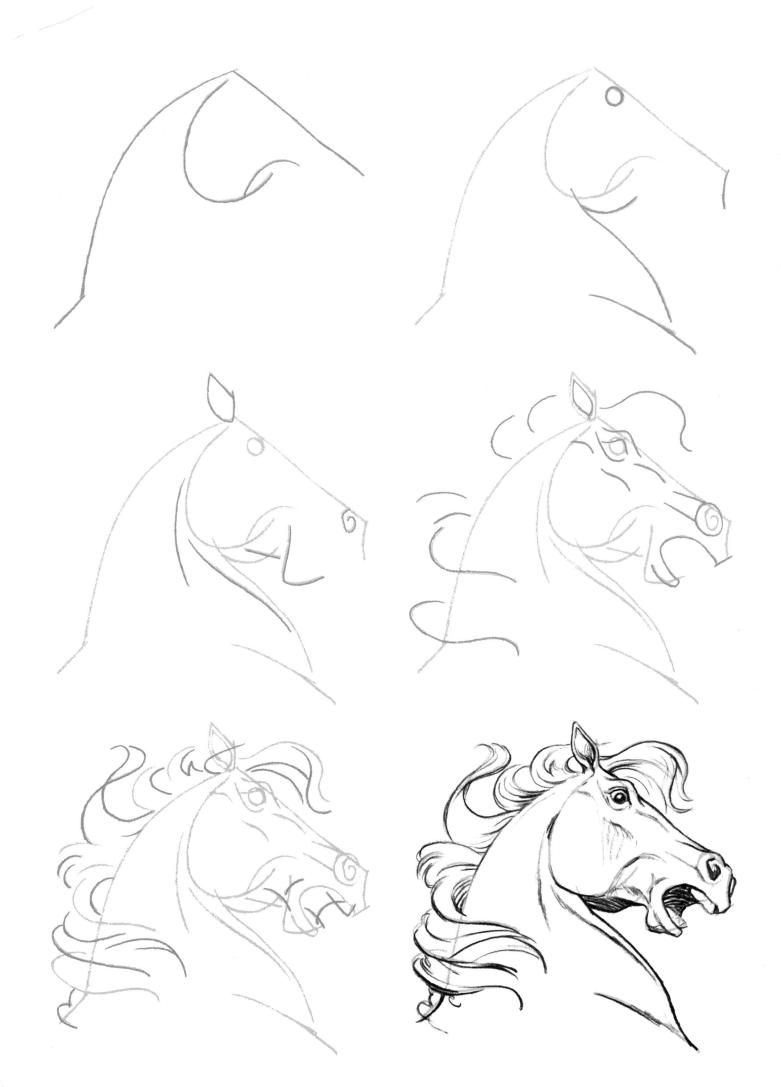

Portrait, rearing

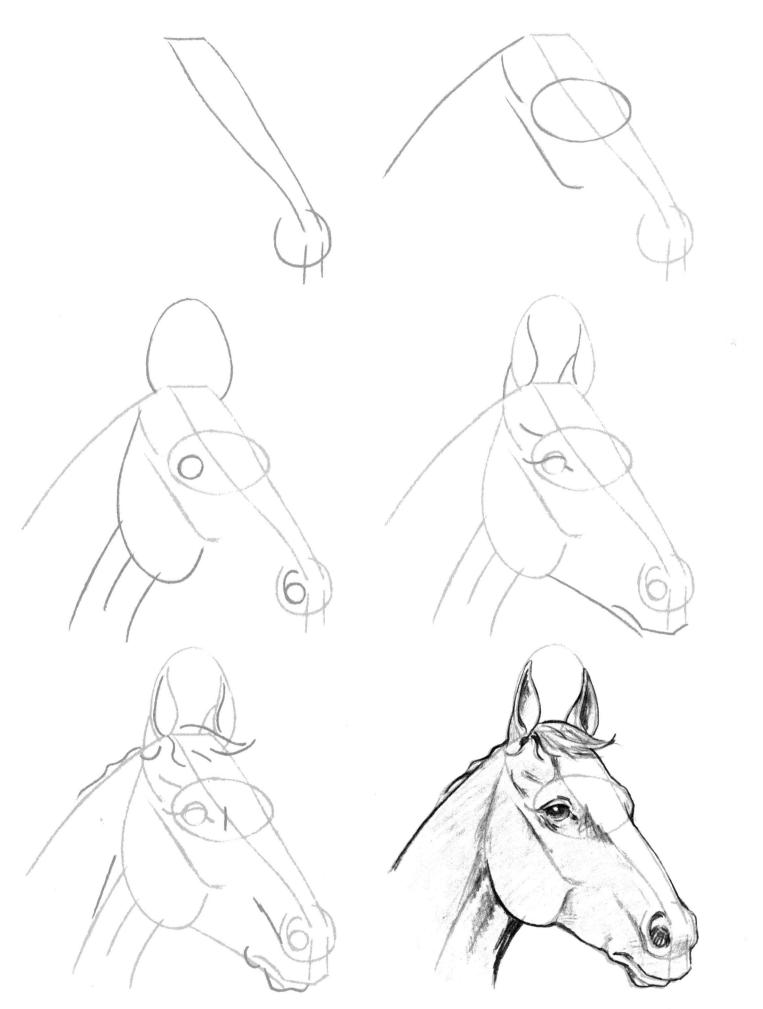

Portrait, blaze

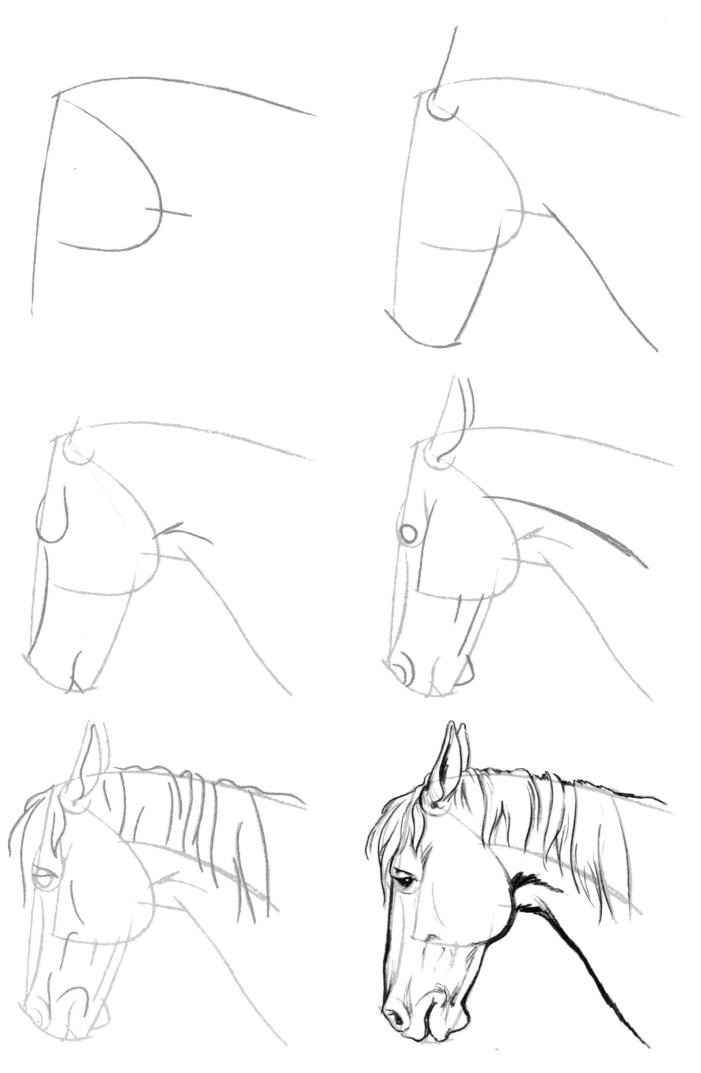

Portrait, nag

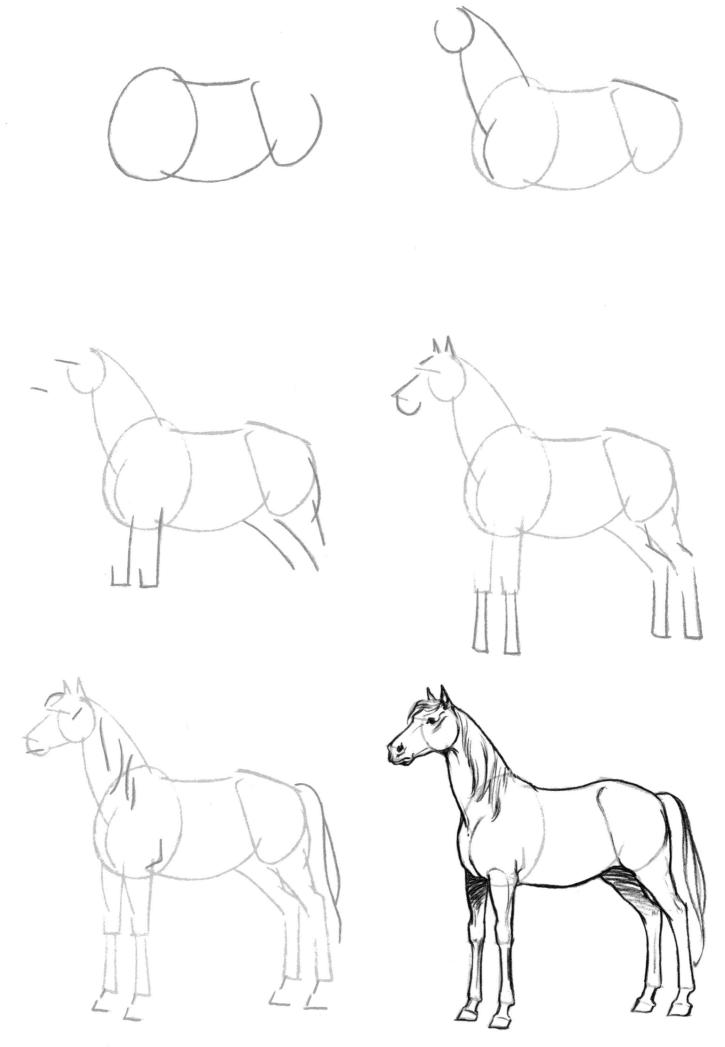

Arabian

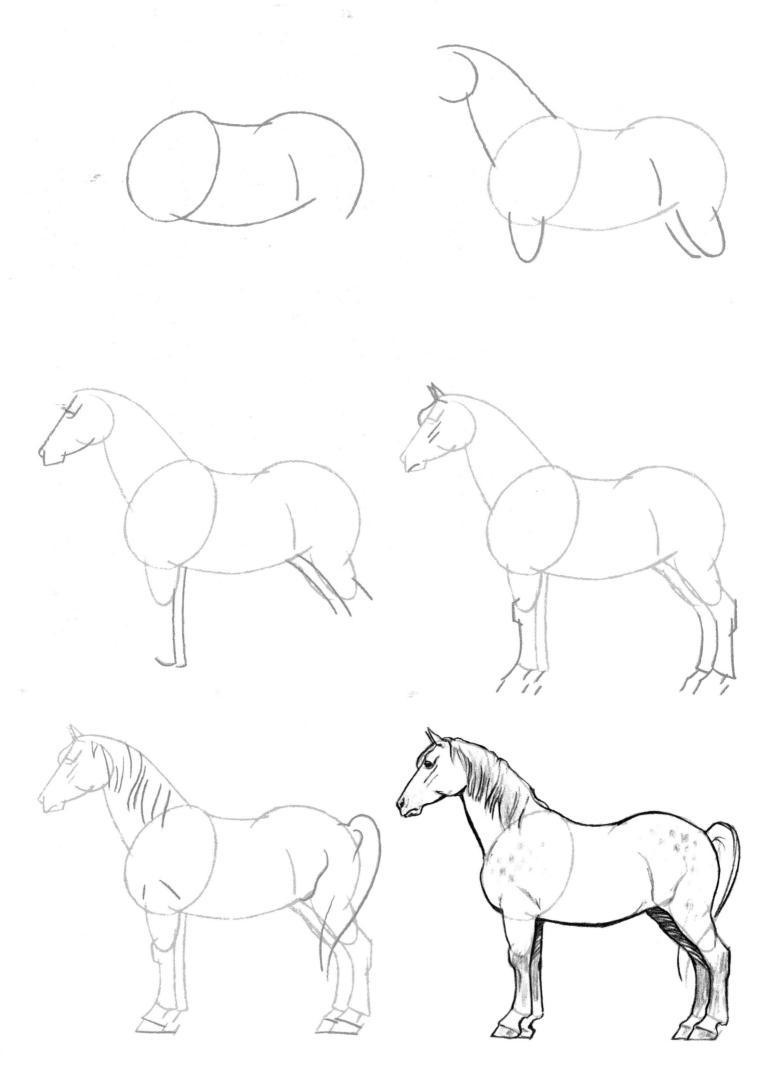

Percheron

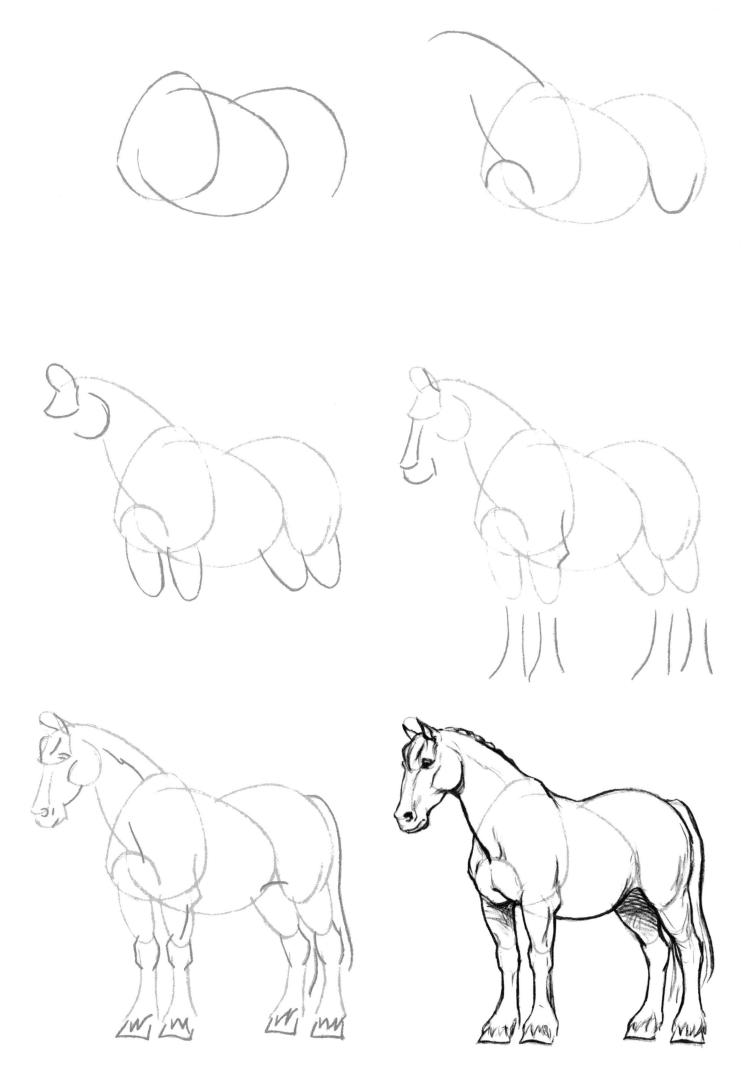

Clydesdale

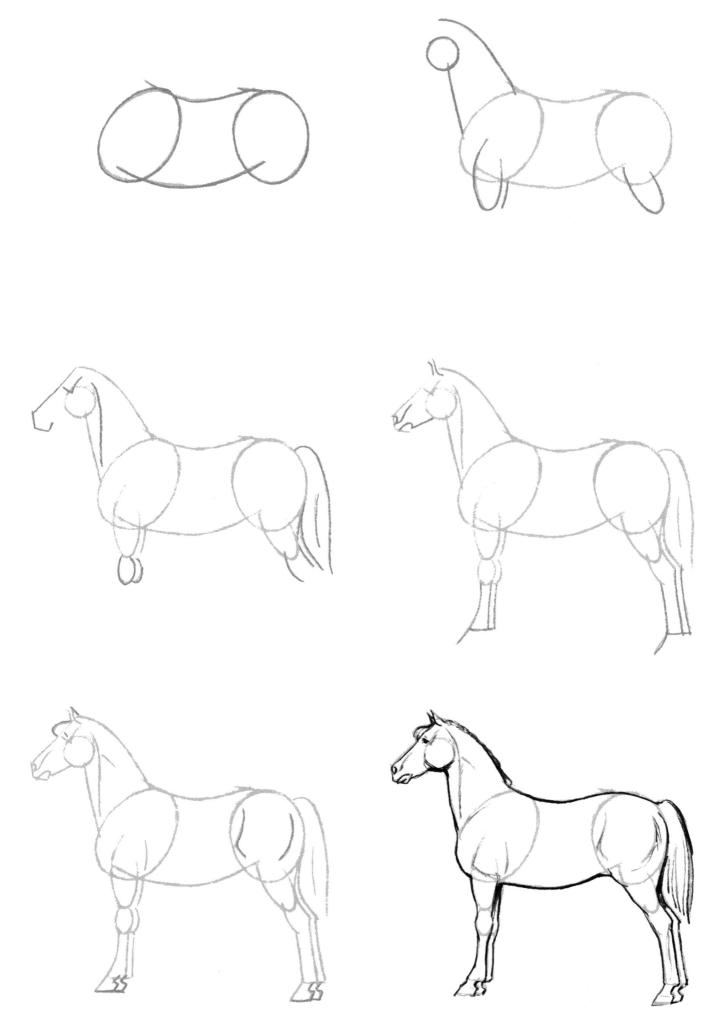

Morgan

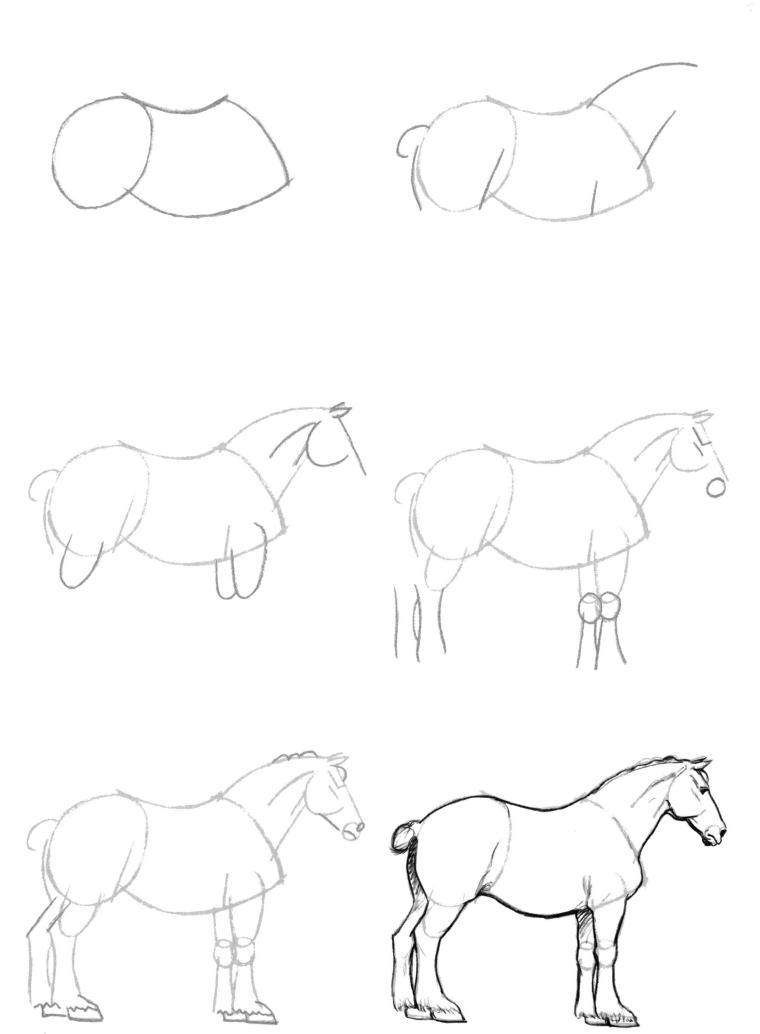

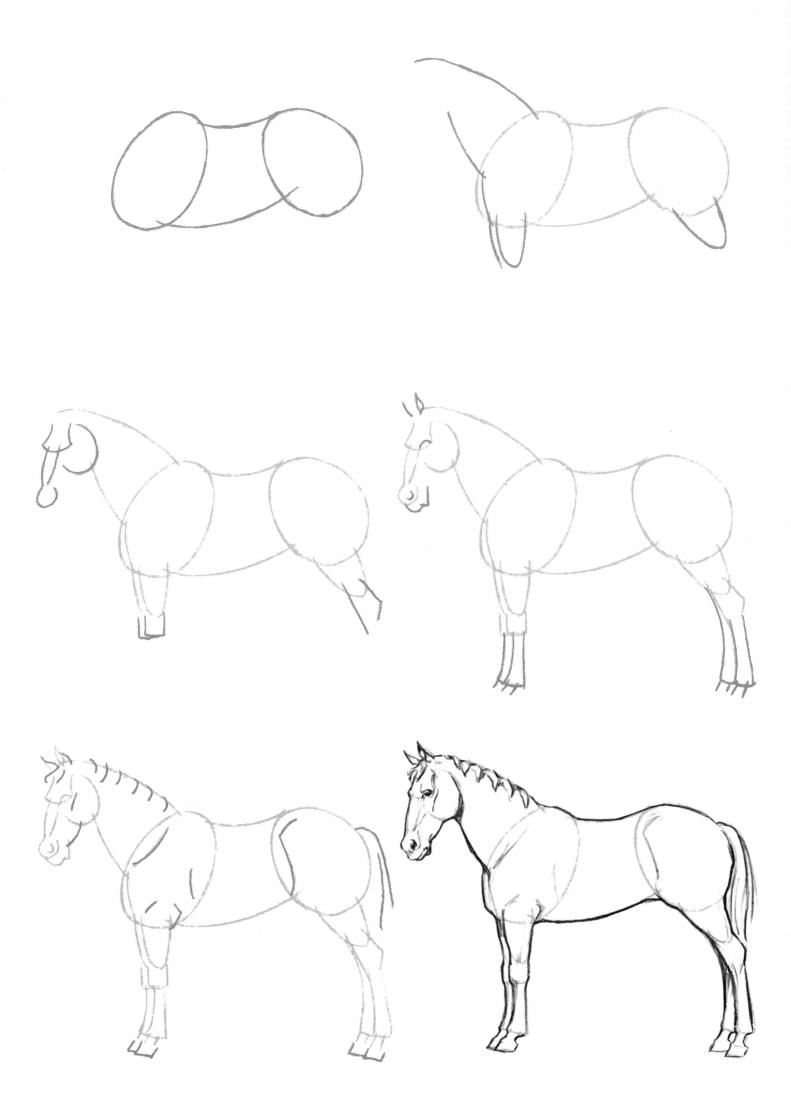

Tennessee Walking Horse

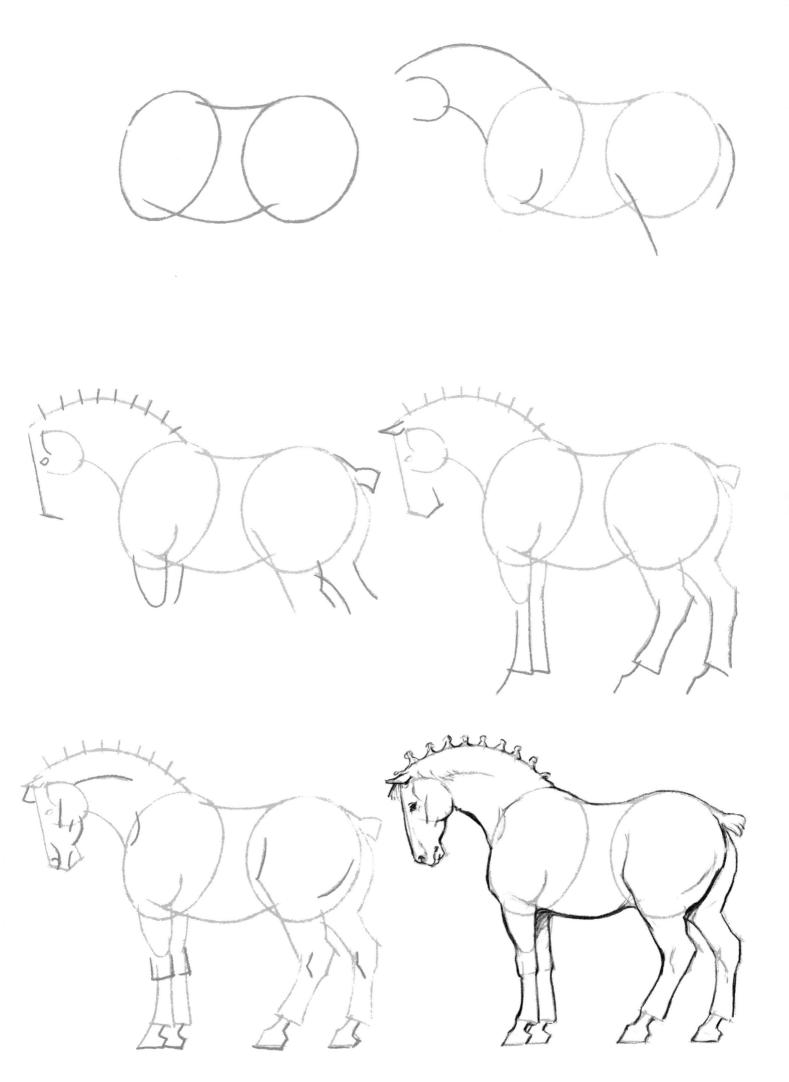

Belgian

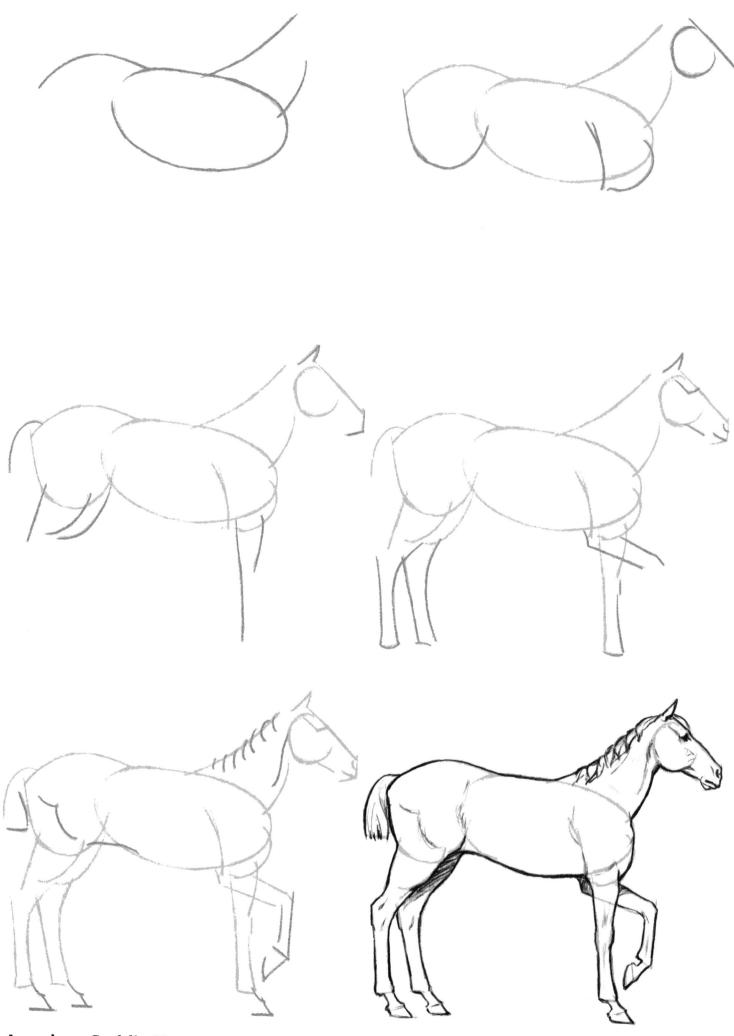

American Saddle Horse

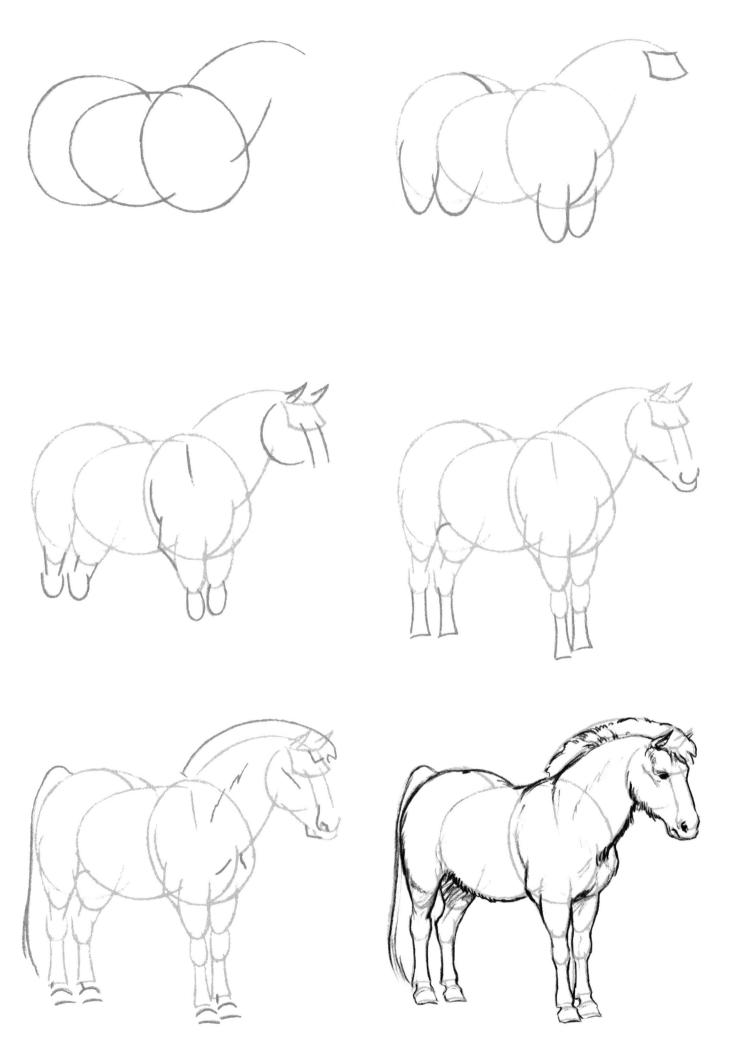

Shetland Pony

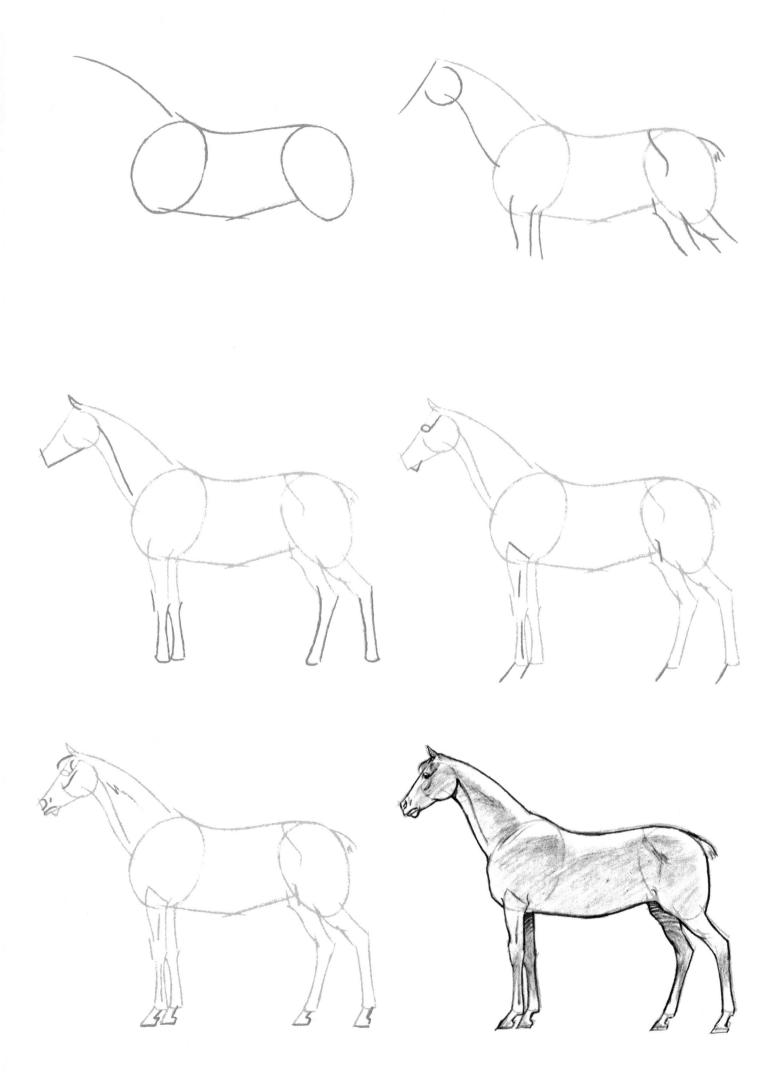

Thoroughbred

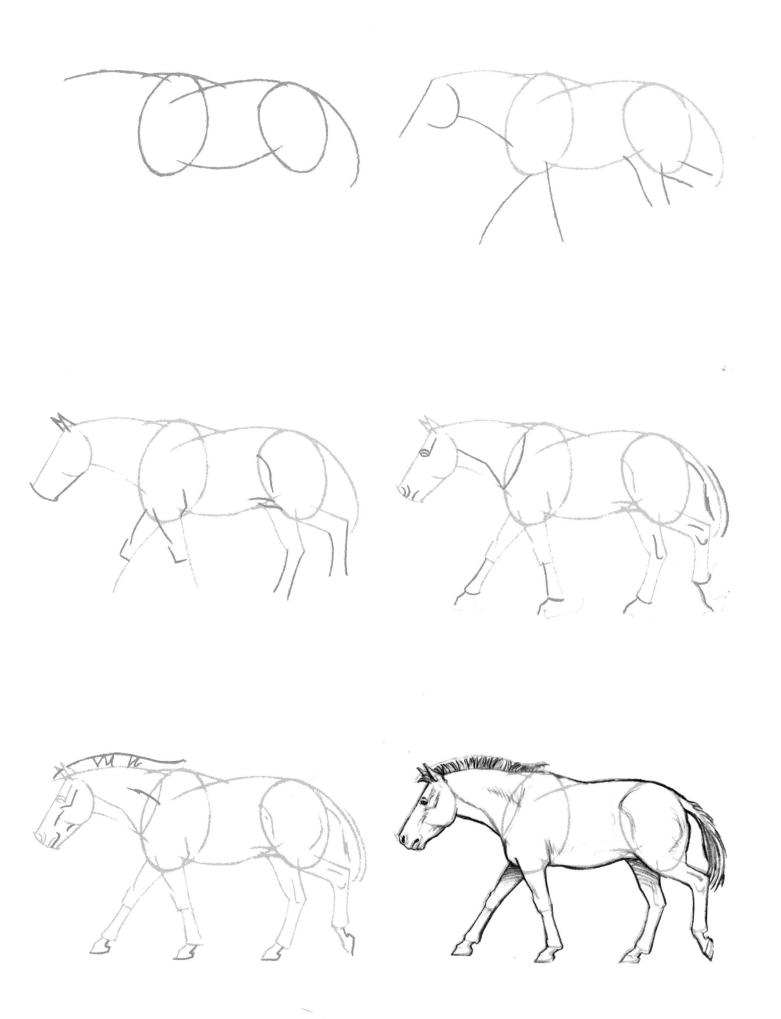

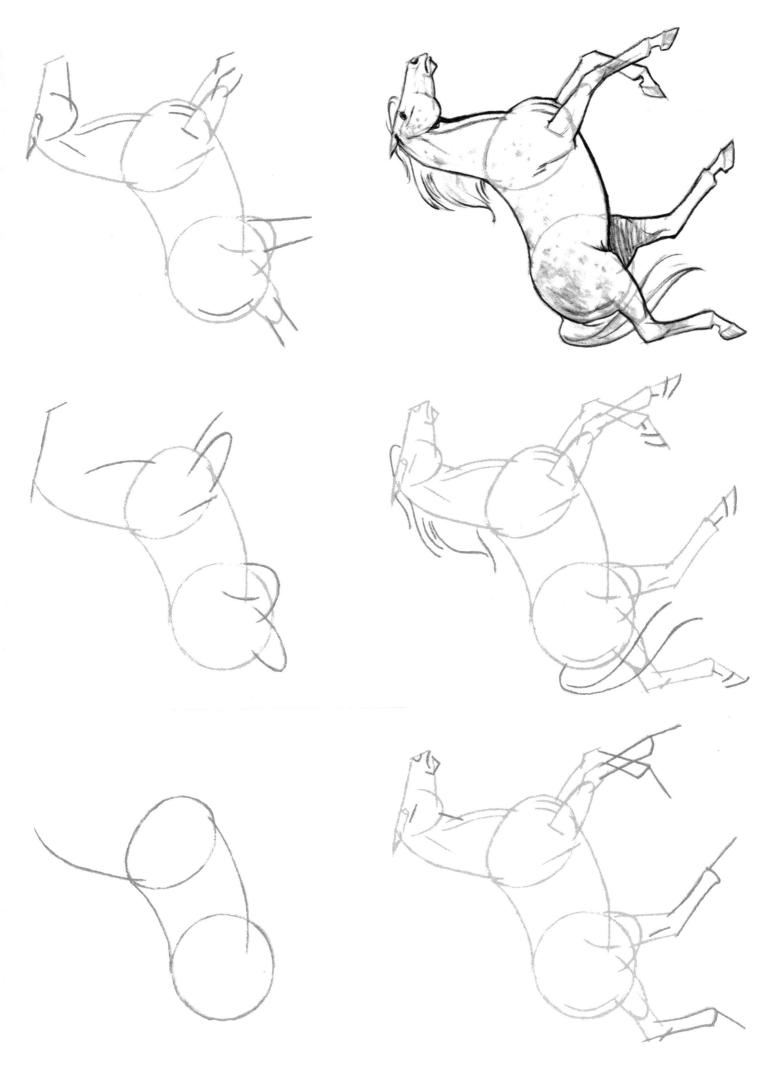

Appaloosa

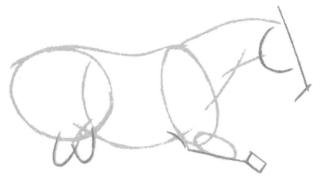

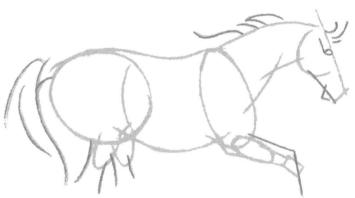

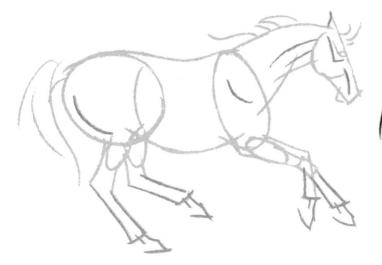

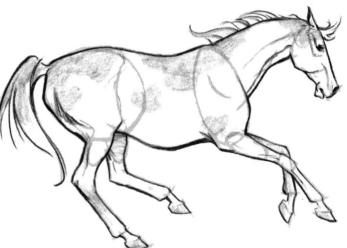

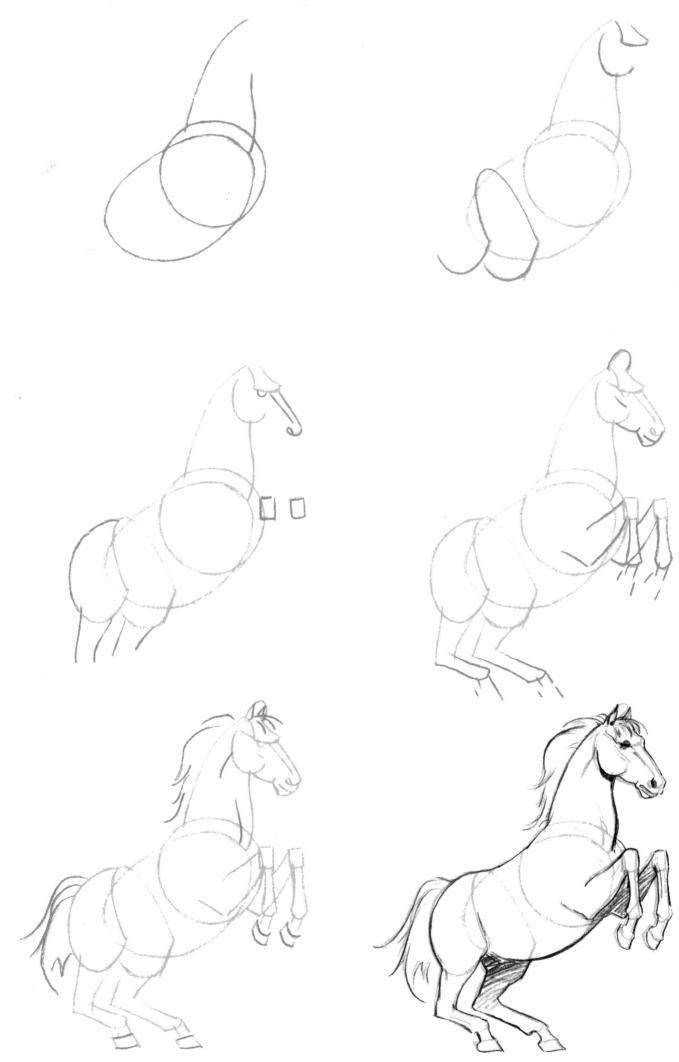

Performing Lippizaner, Levade

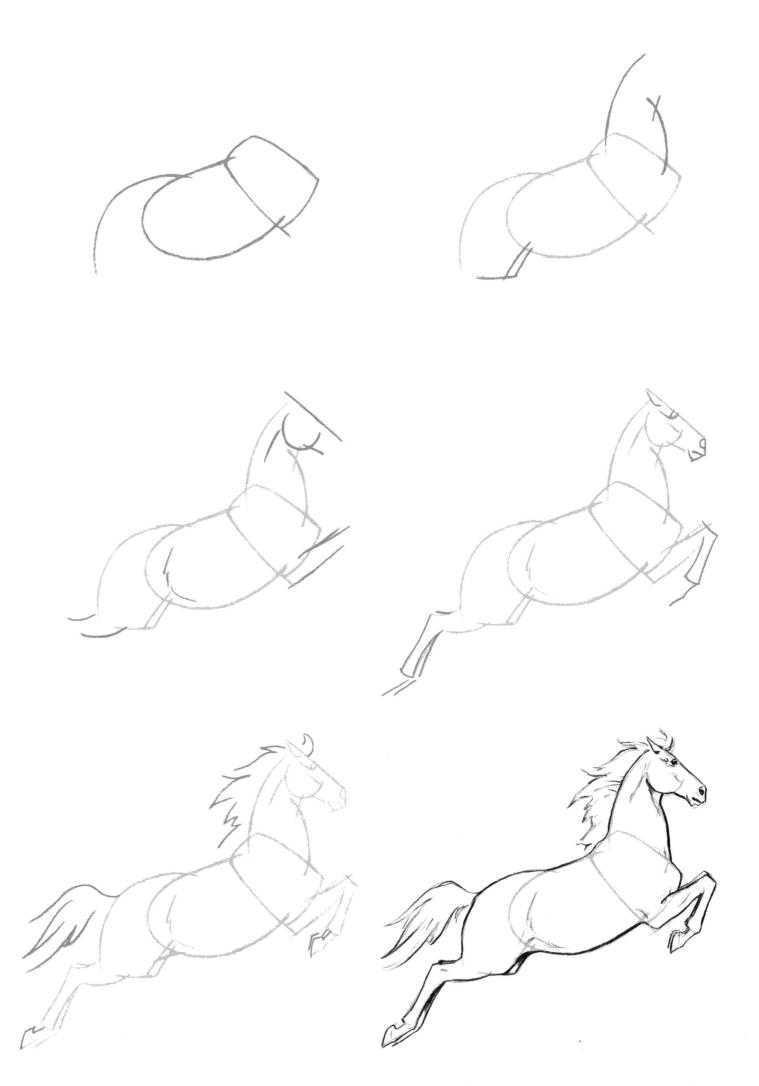

Performing Lippizaner, Capriole

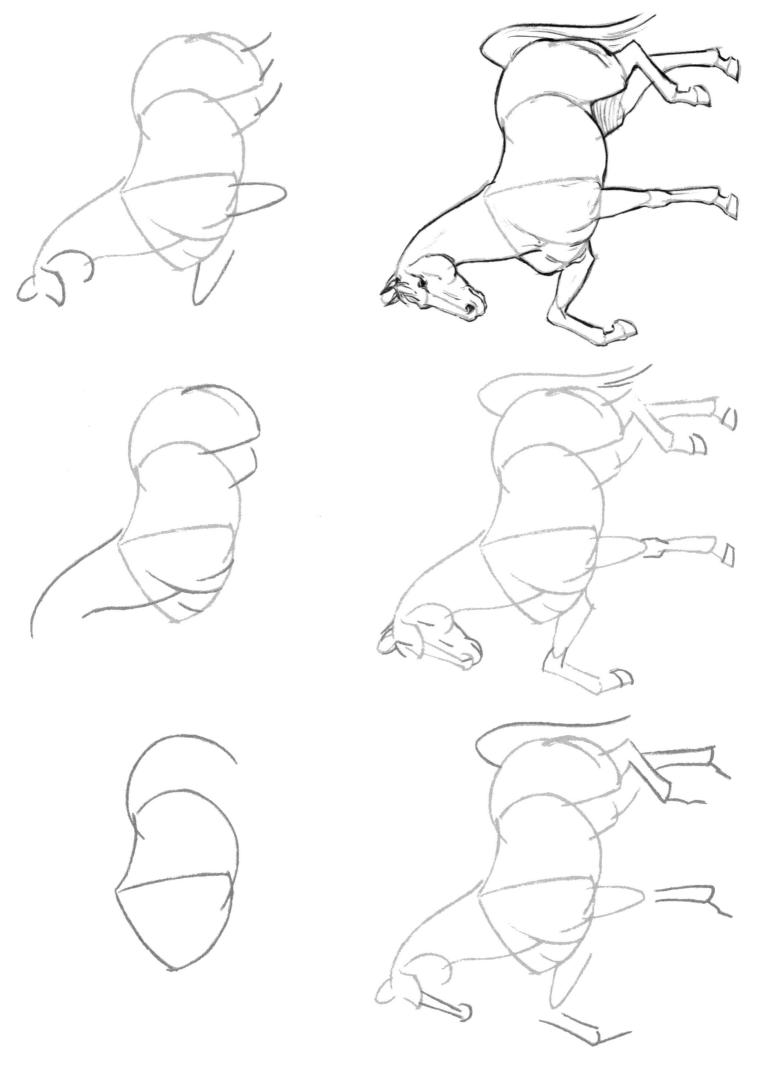

Performing Lippizaner, Piaffe

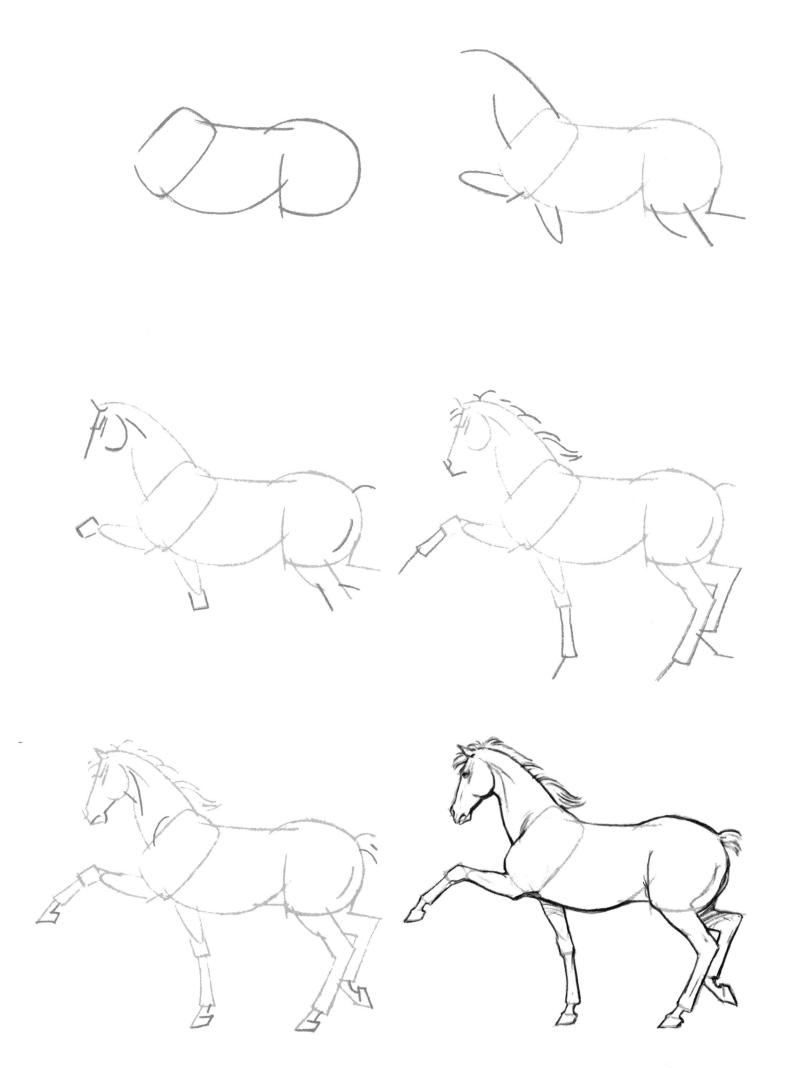

Tennessee Walking Horse, High-Stepping

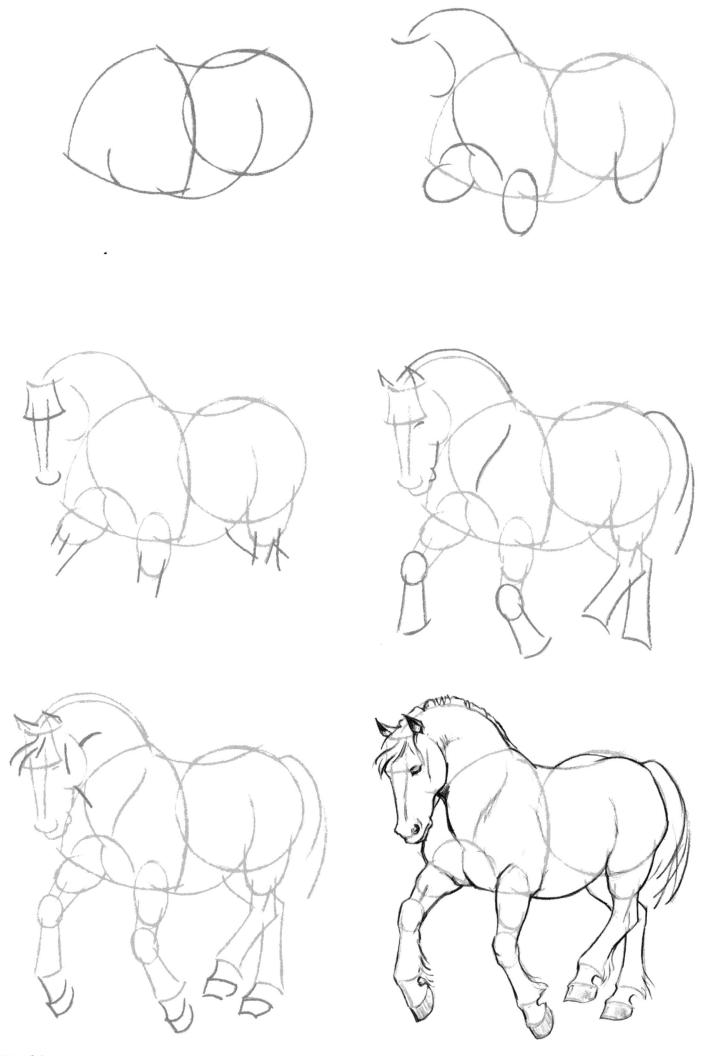

Workhorse

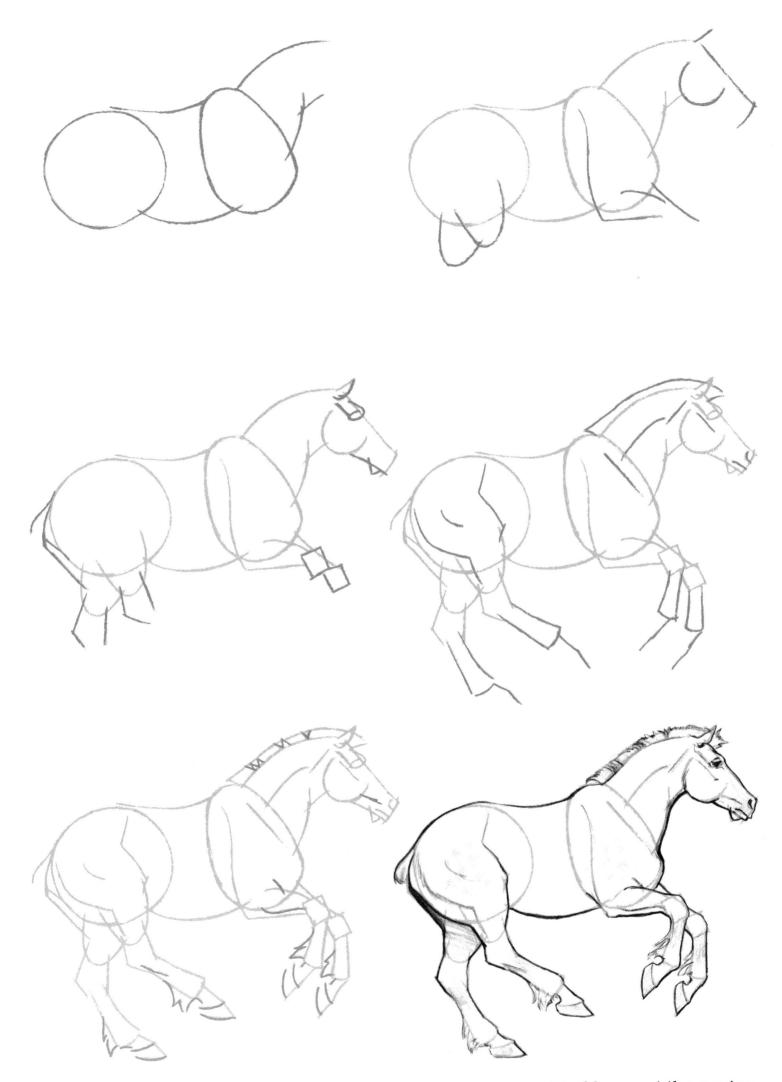

Workhorse at the canter

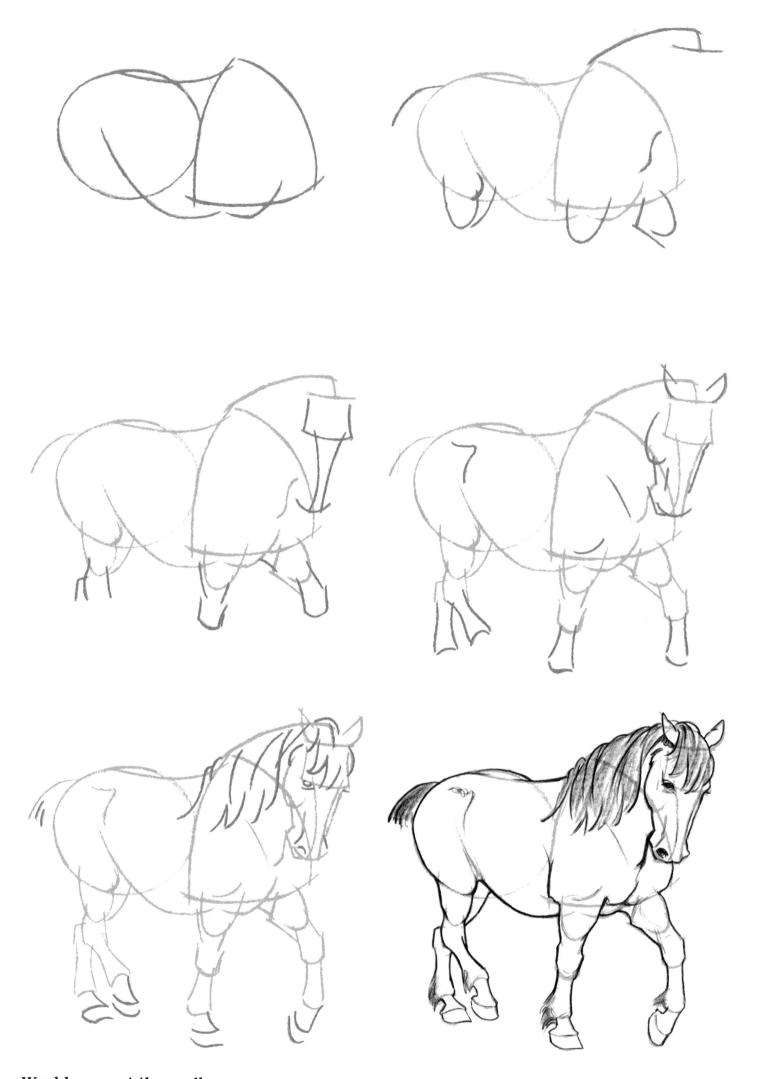

Workhorse at the walk

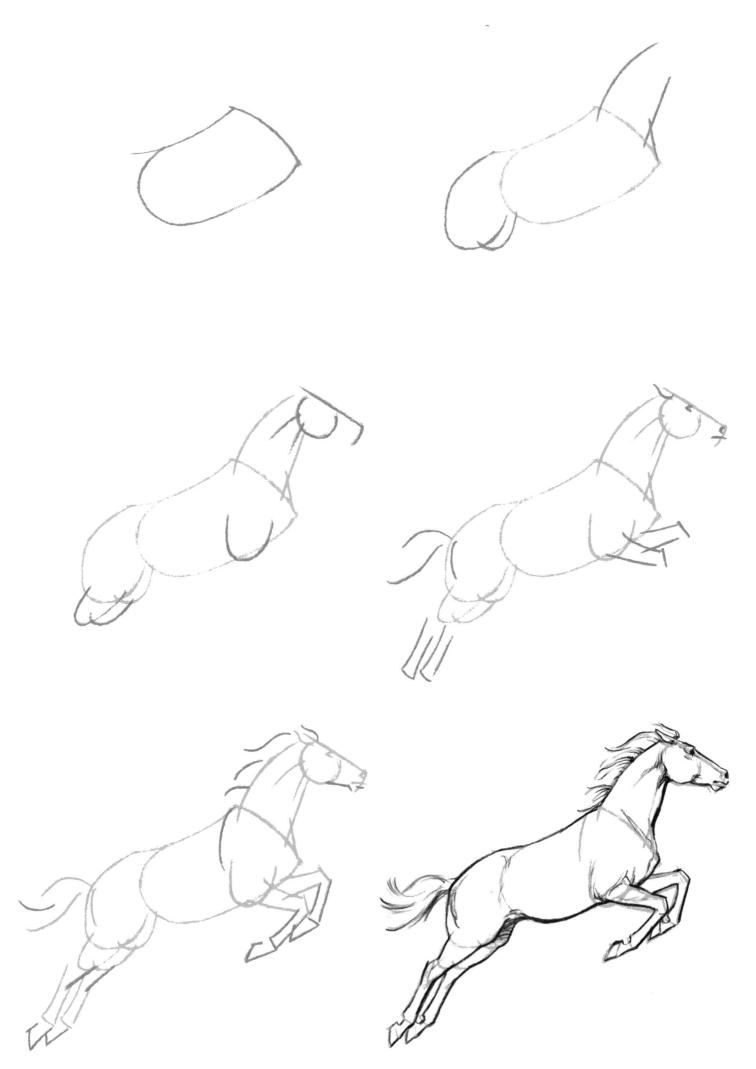

Jumping #1

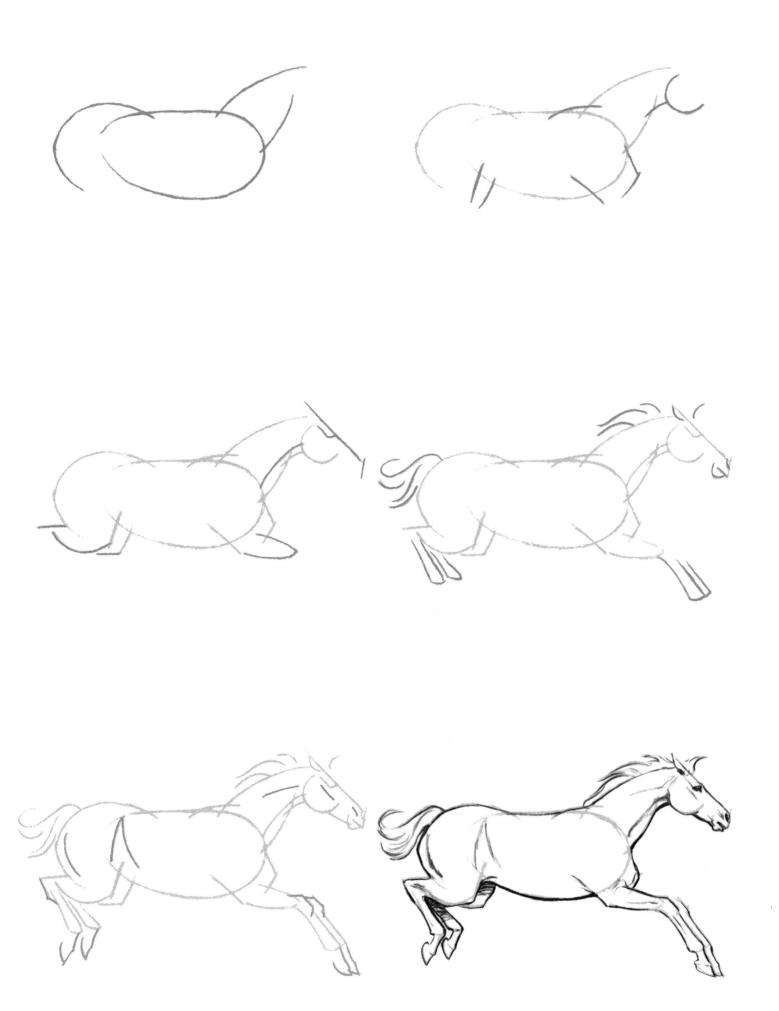

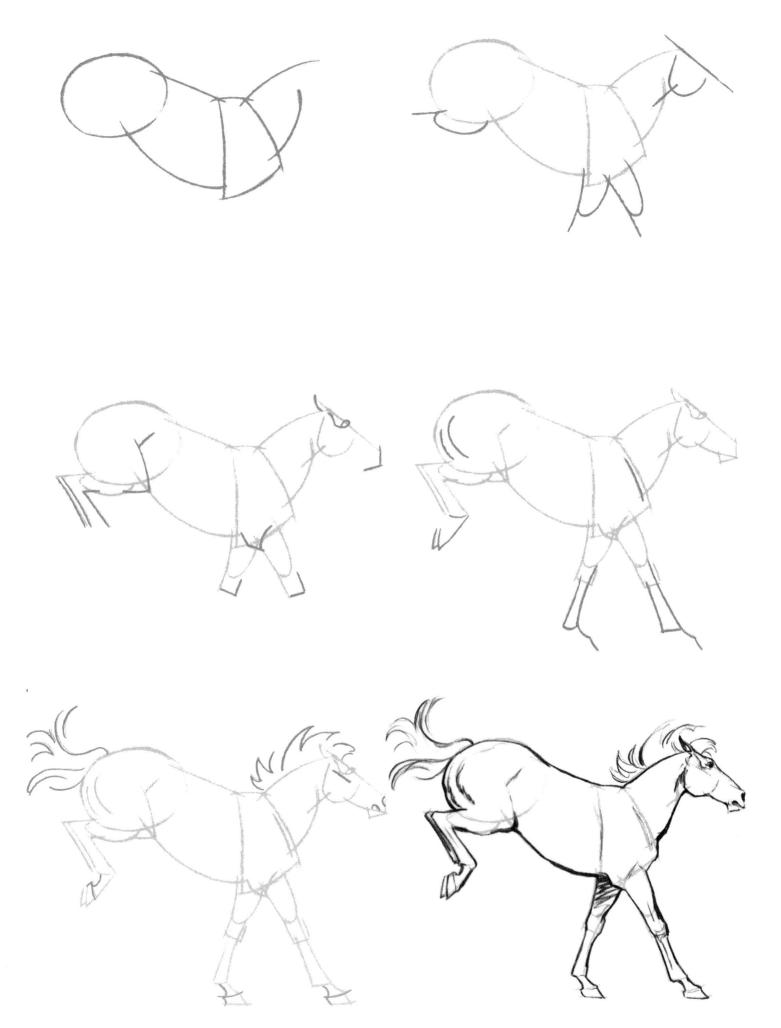

Jumping #3

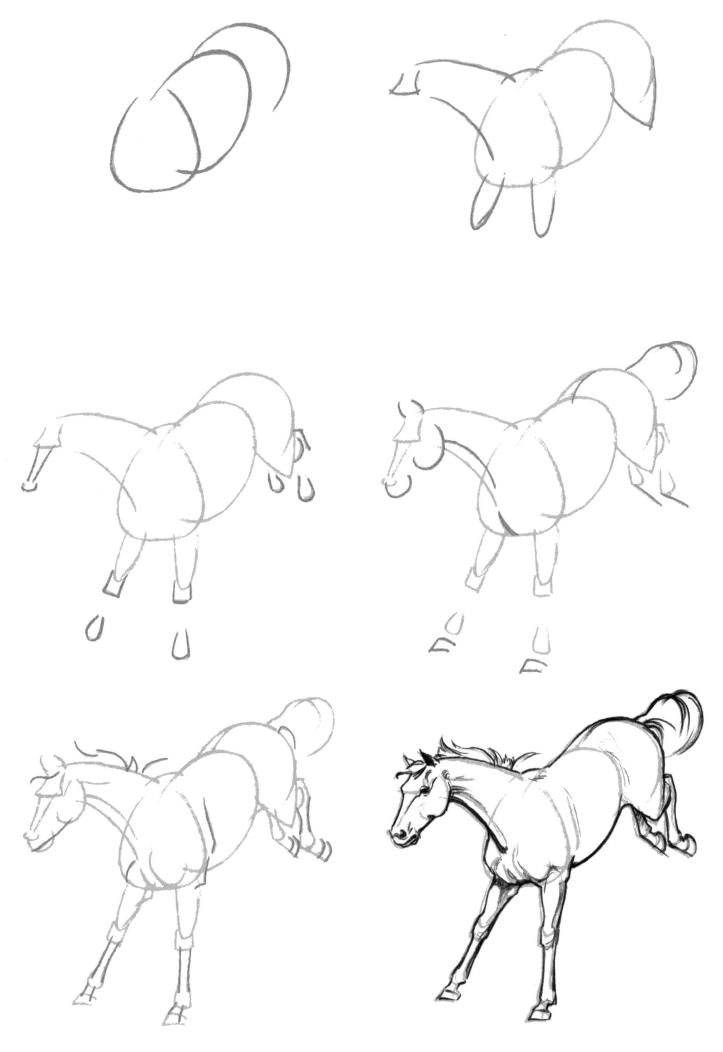

Jumping #4

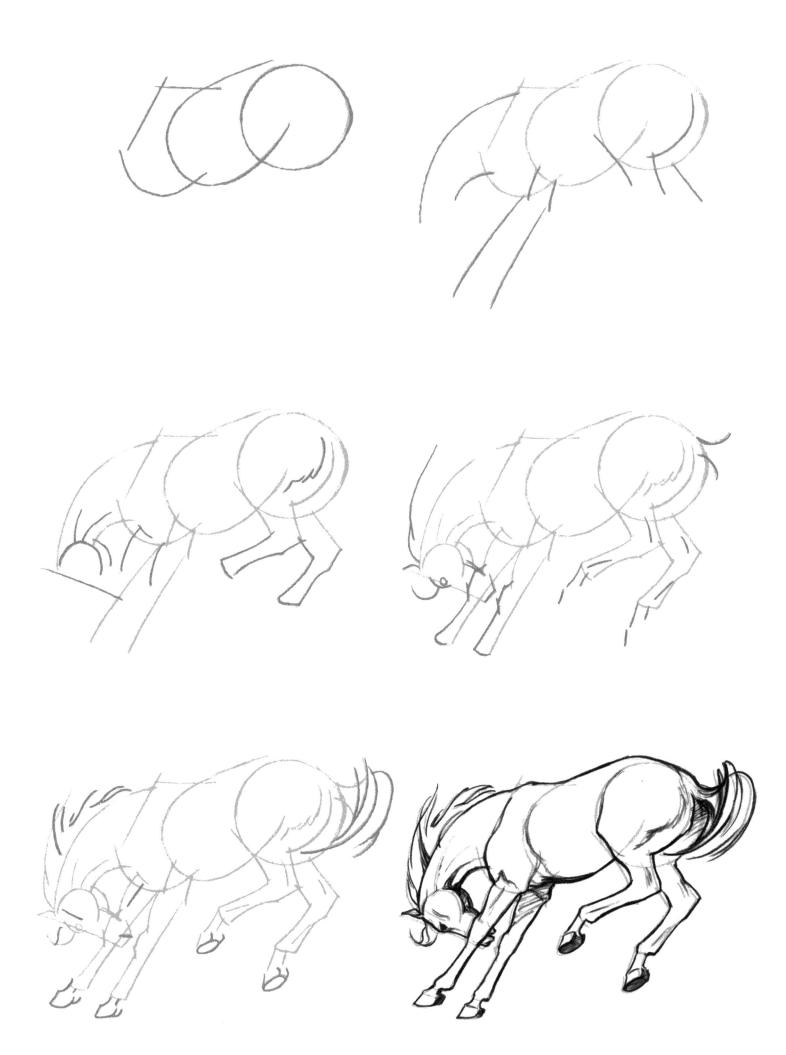

Bucking #1

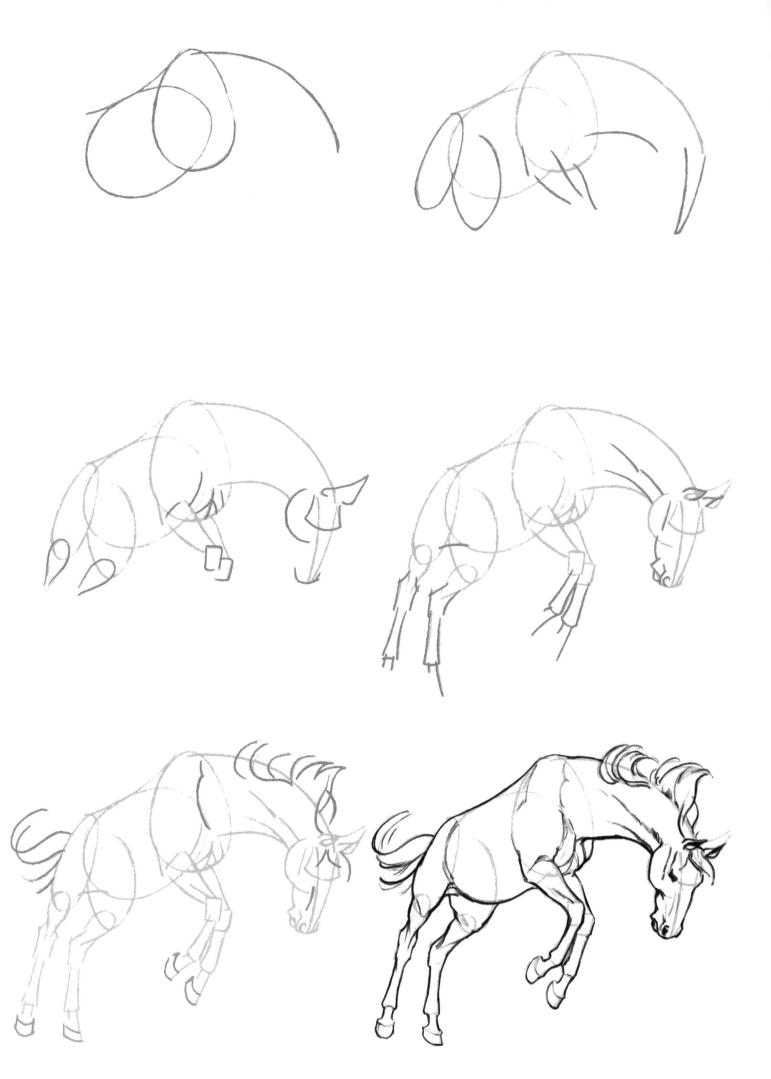

Bucking #2

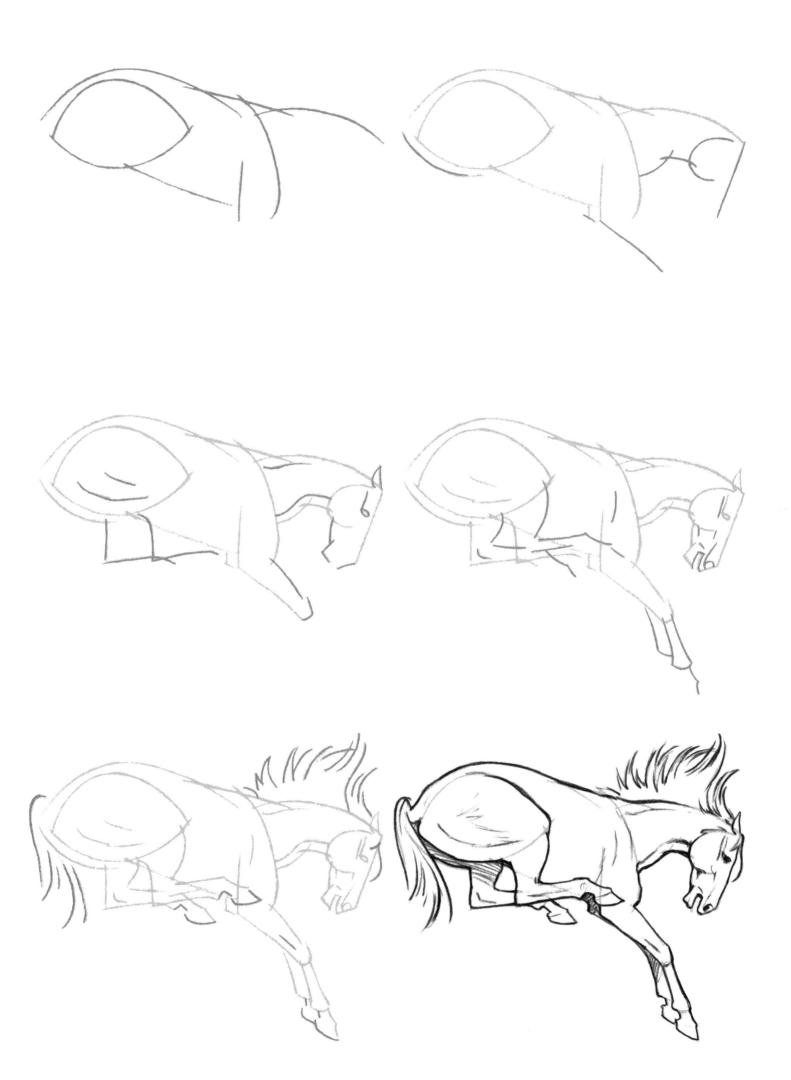

Bucking #3

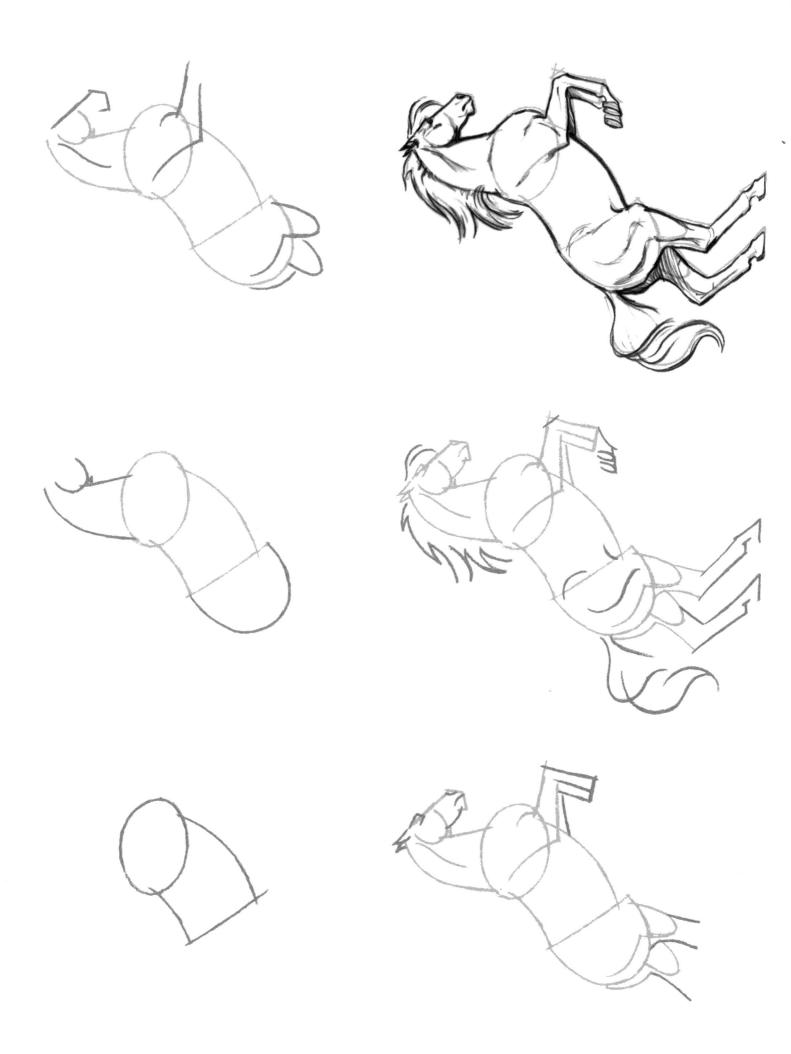

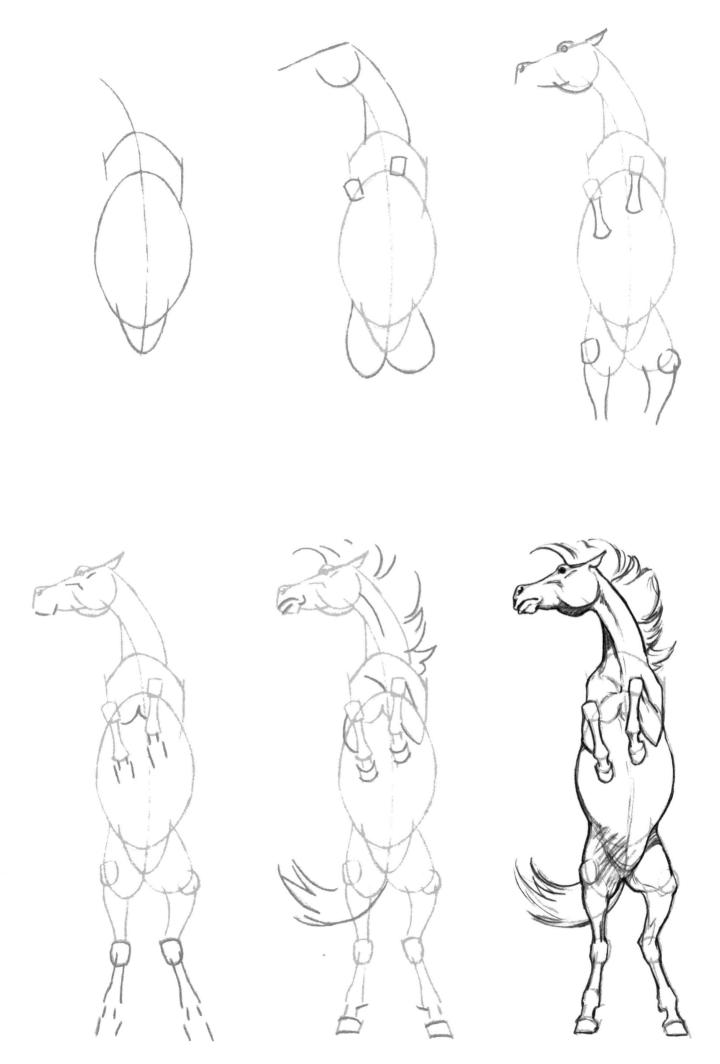

Rearing, front view

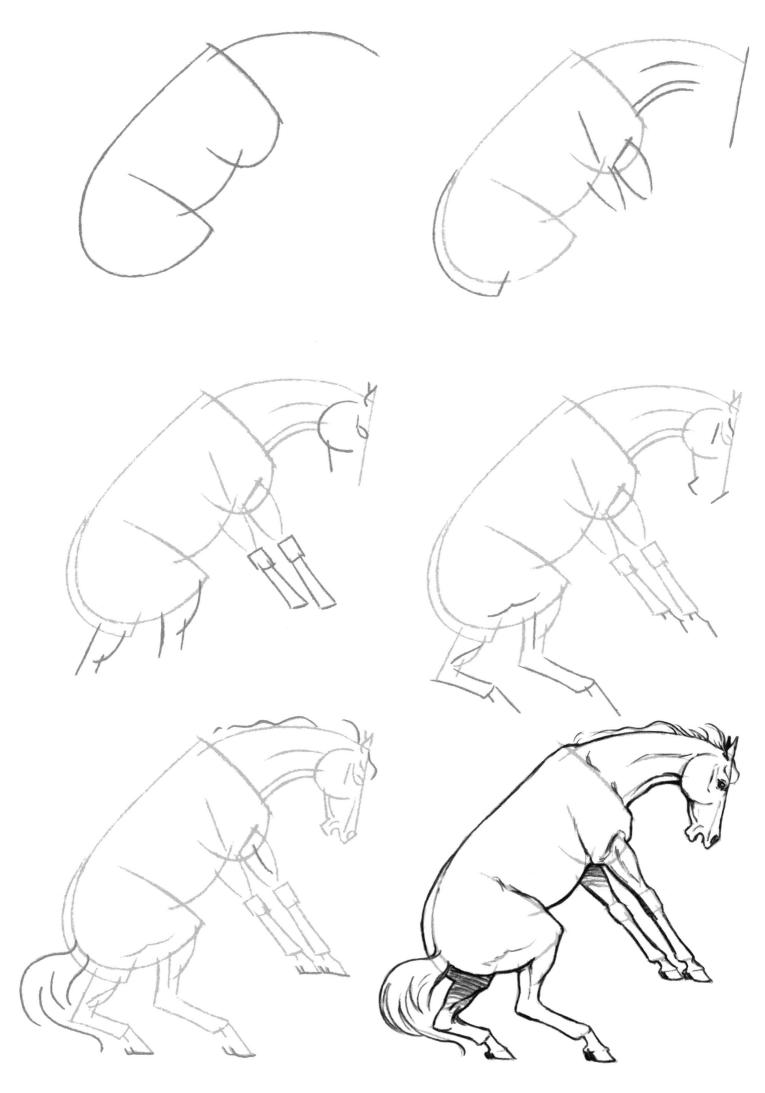

Shying

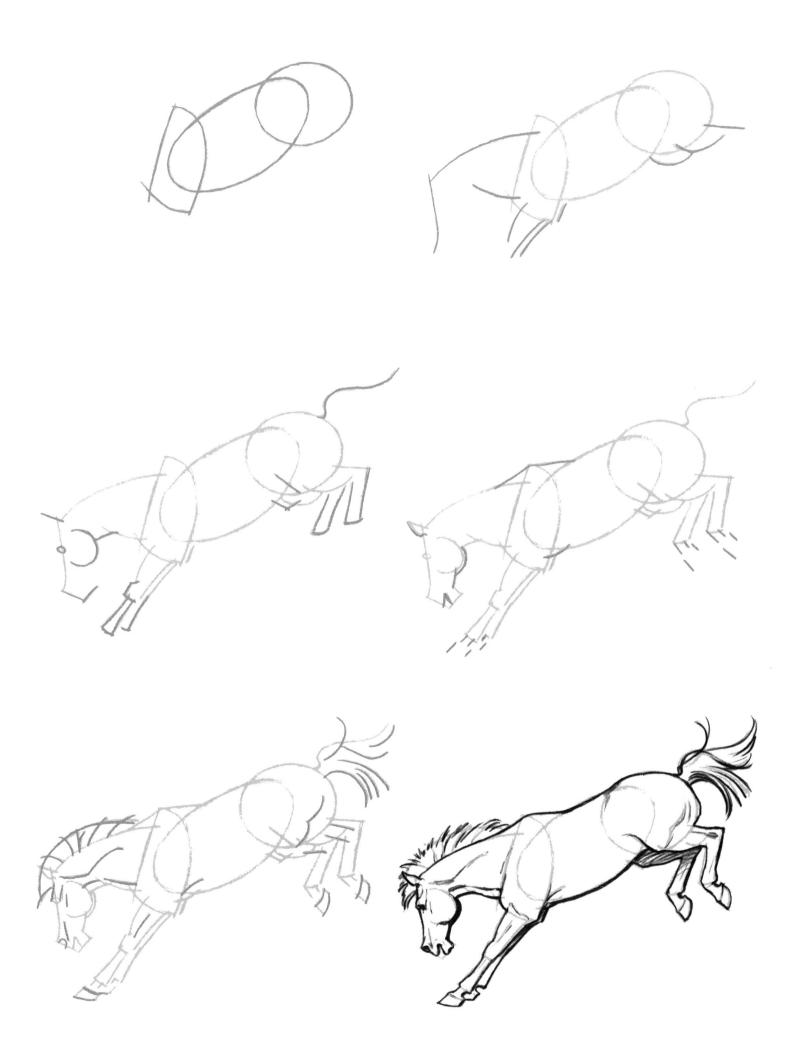

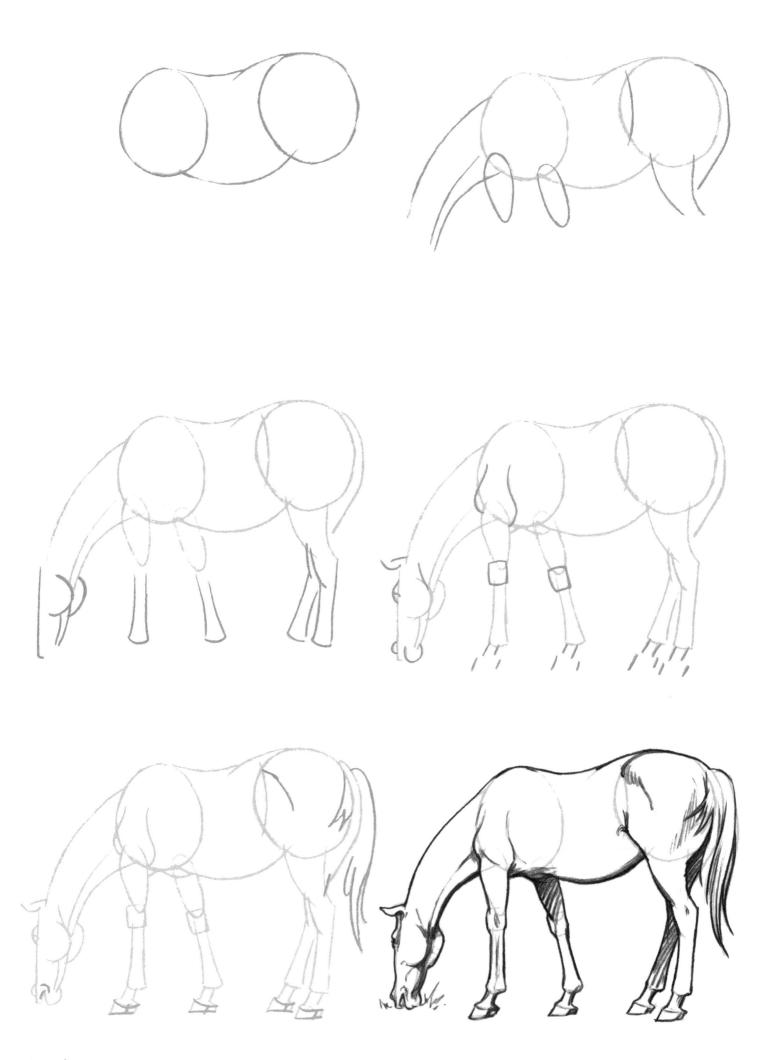

Grazing

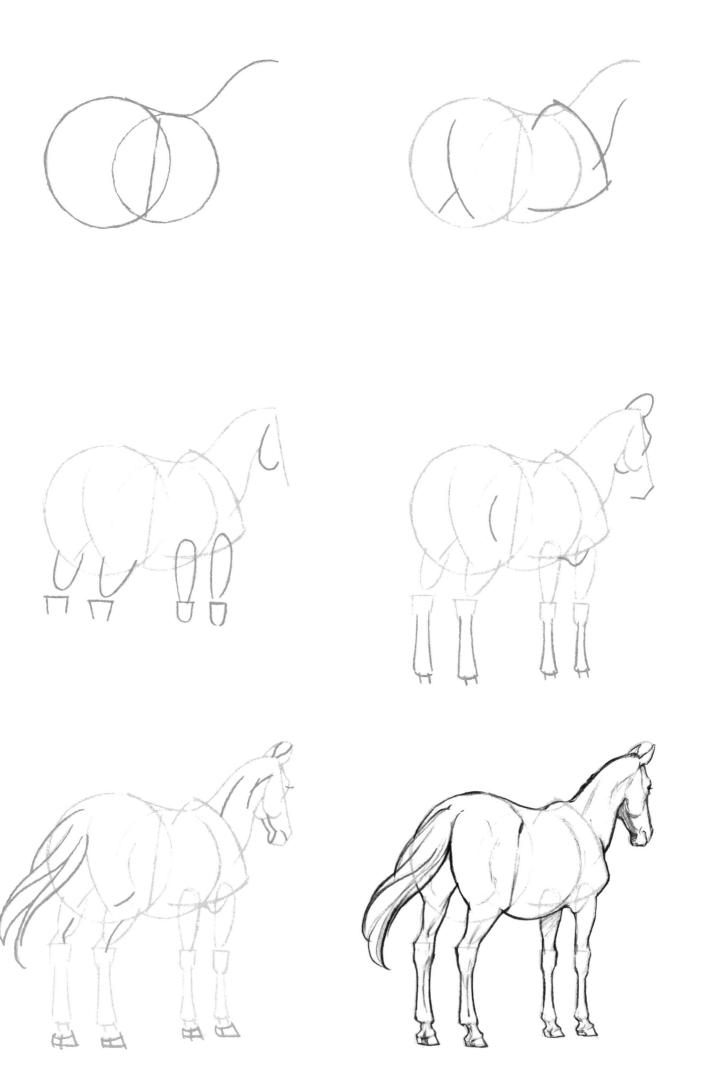

Standing, rear view

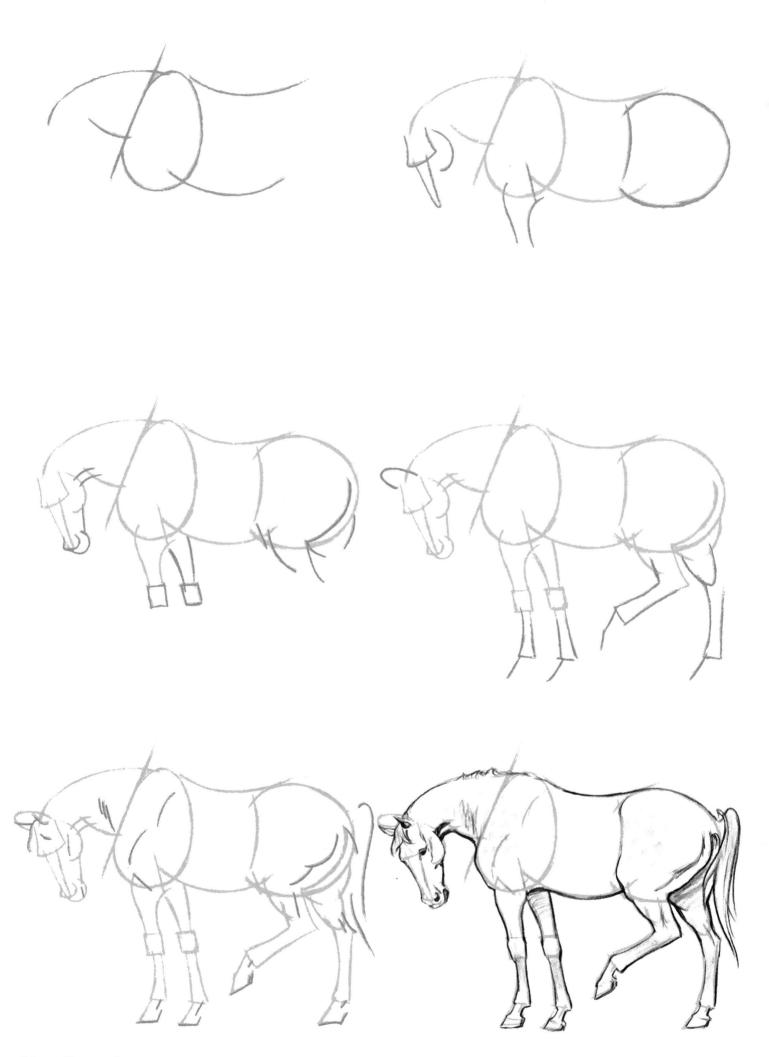

Standing, side view

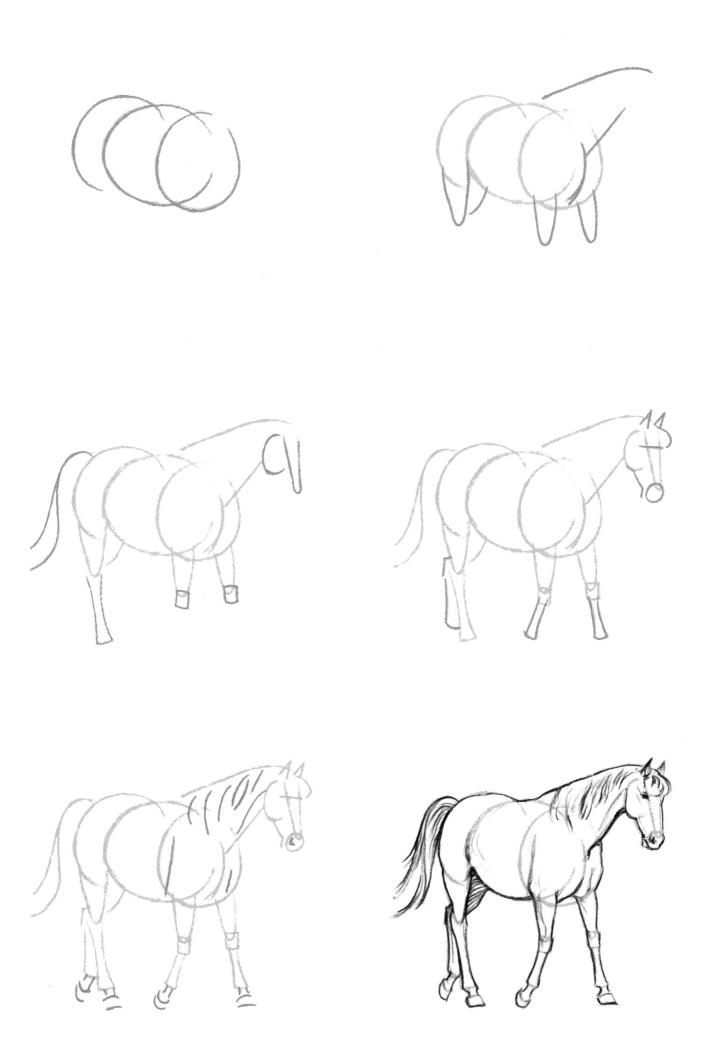

Walking, three-quarter view

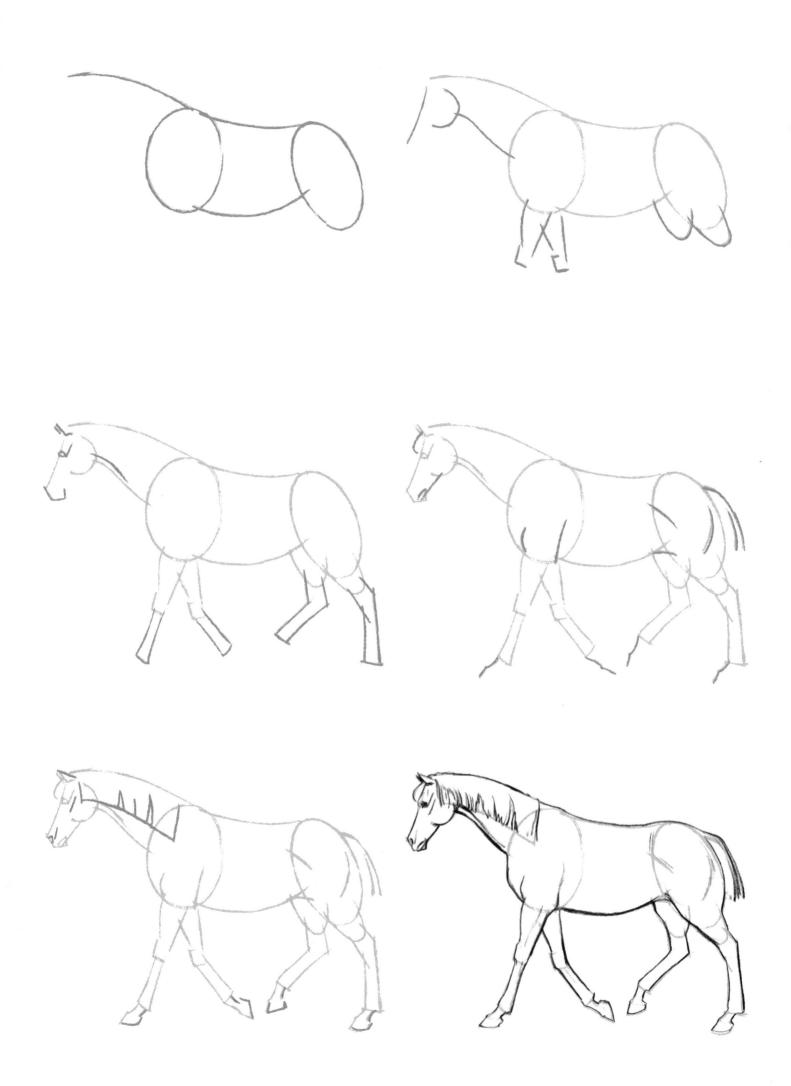

Walking, side view

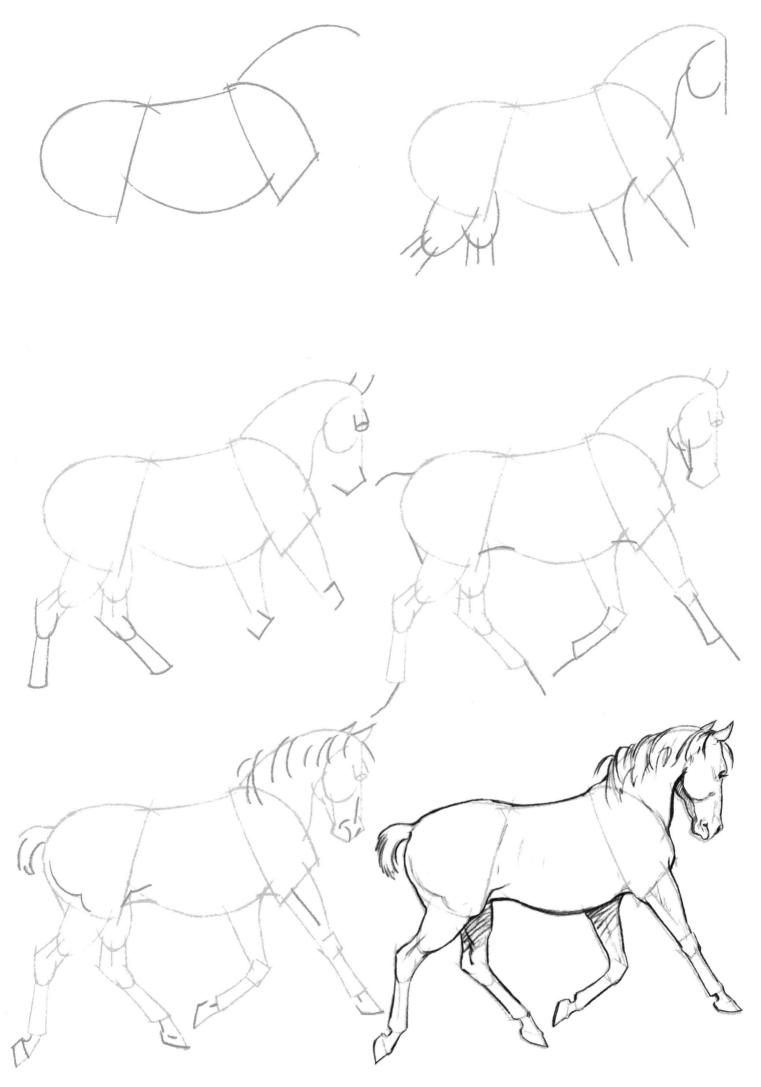

Trotting, side view

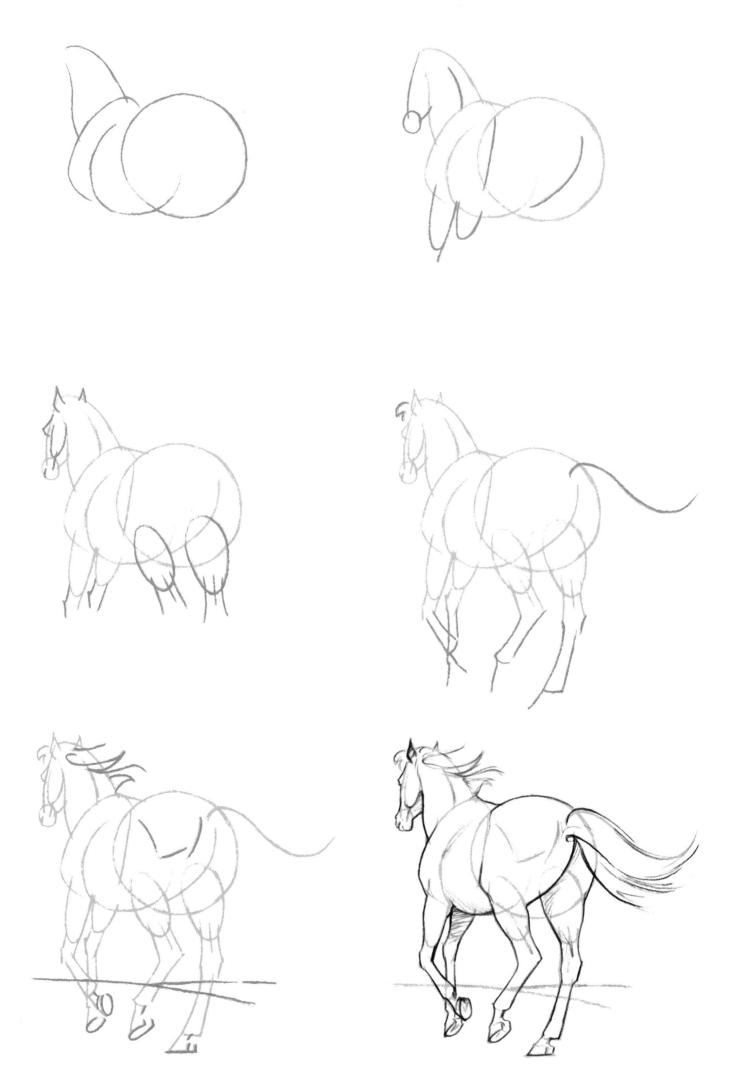

Trotting, rear view

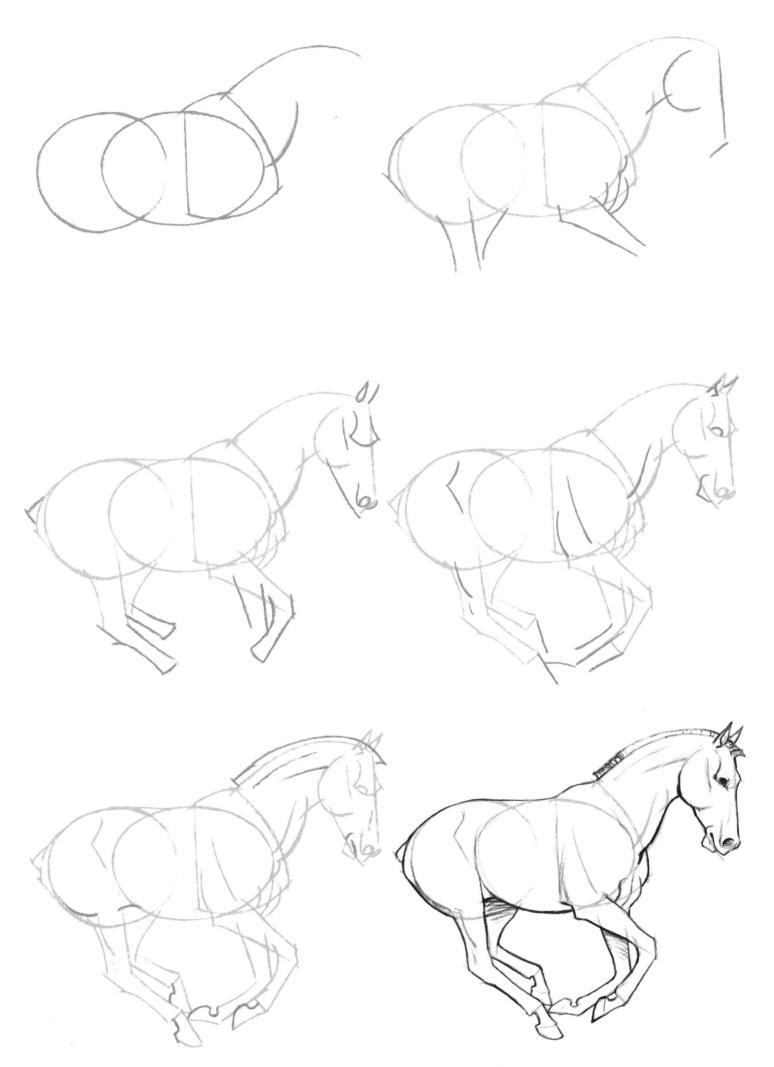

Cantering #1

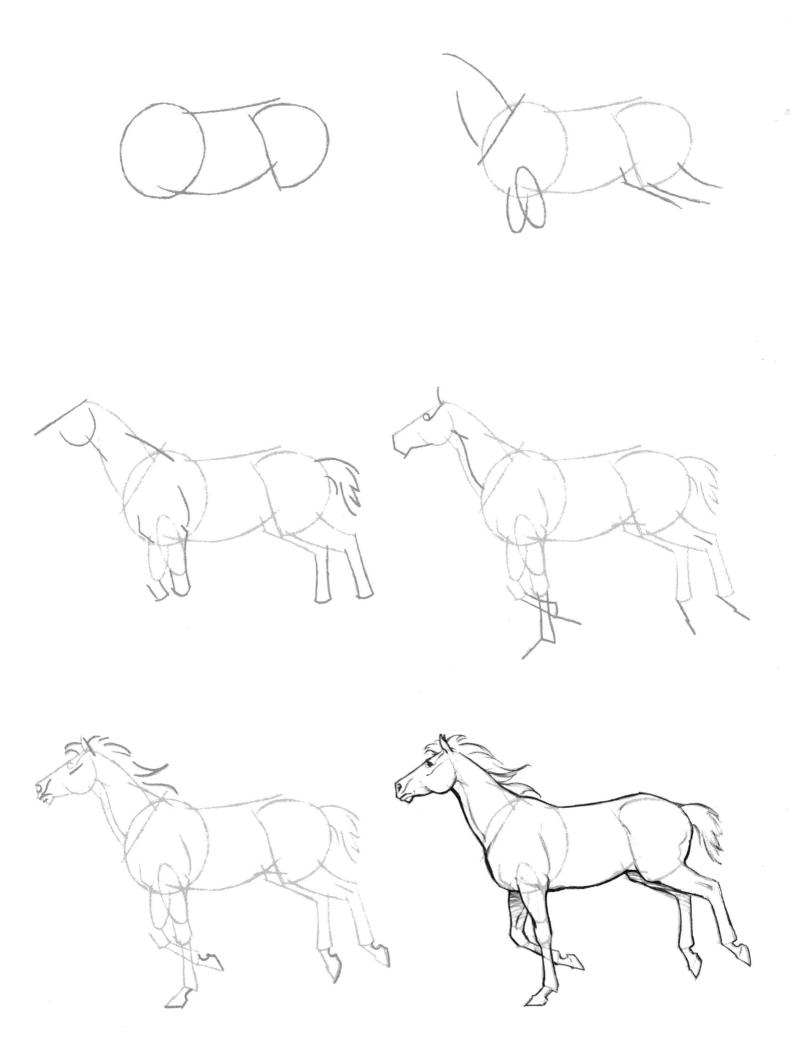

Cantering #2

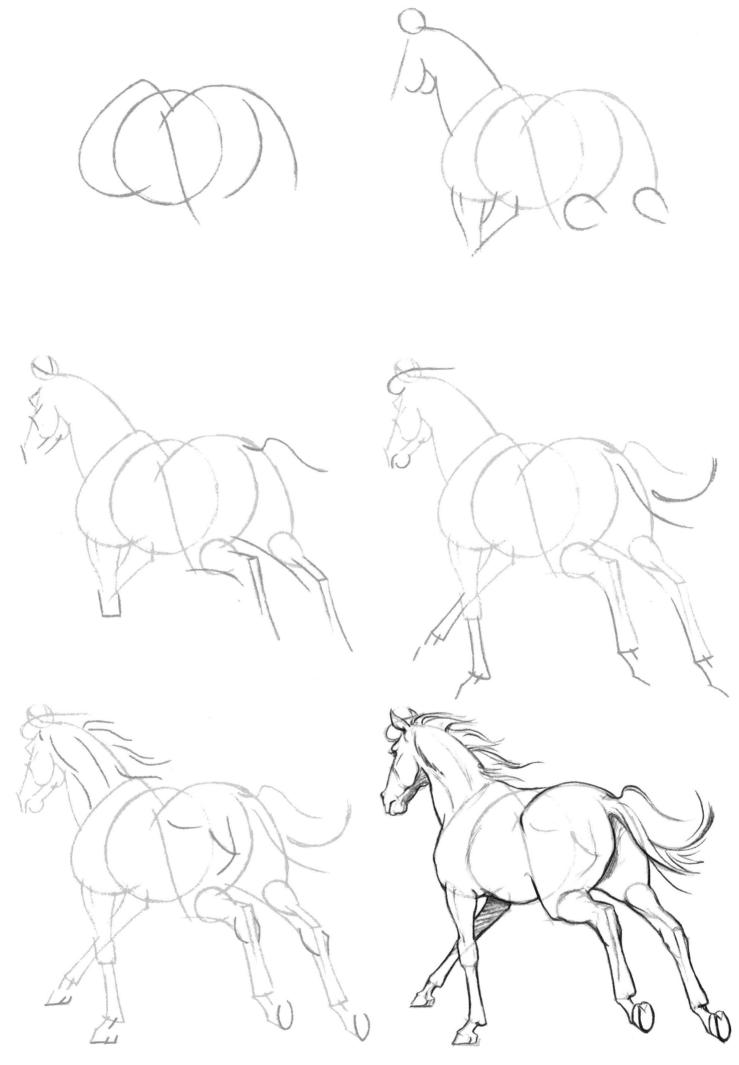

Galloping, rear view

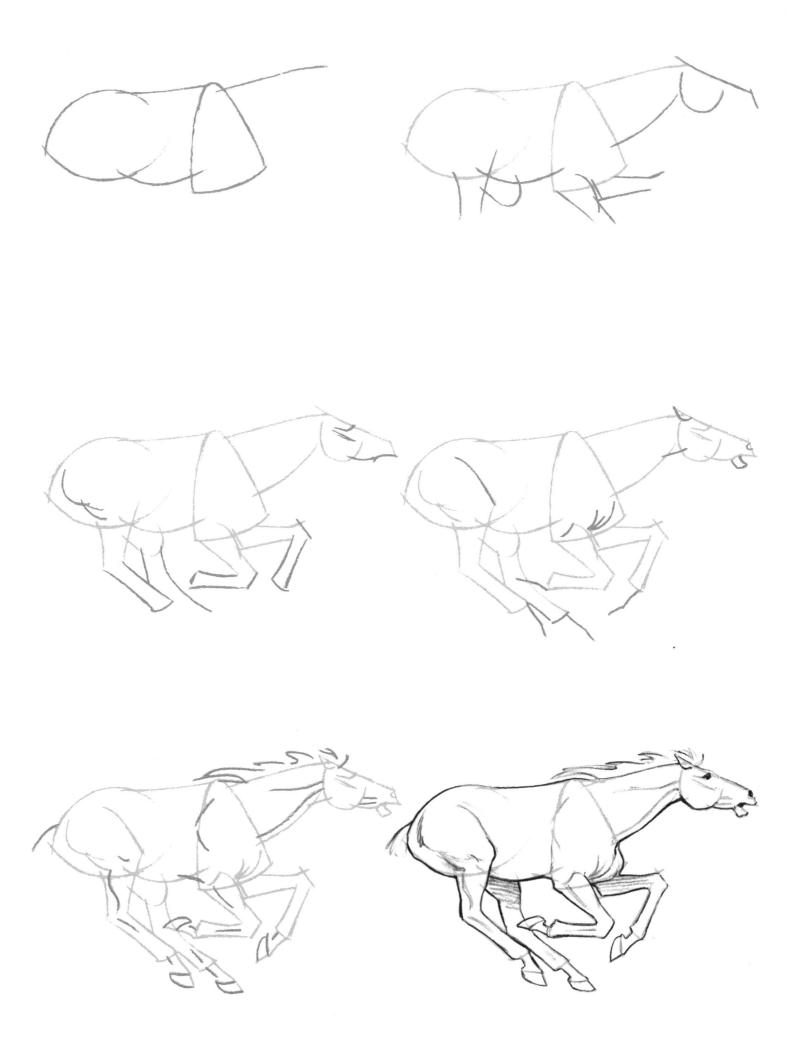

Galloping, side view

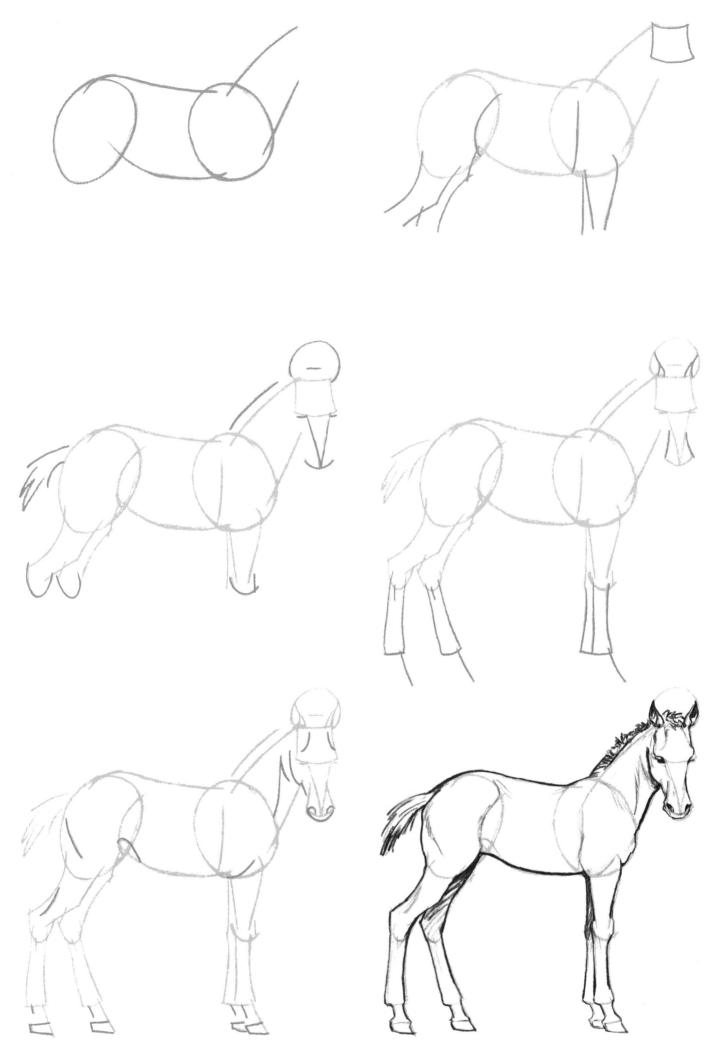

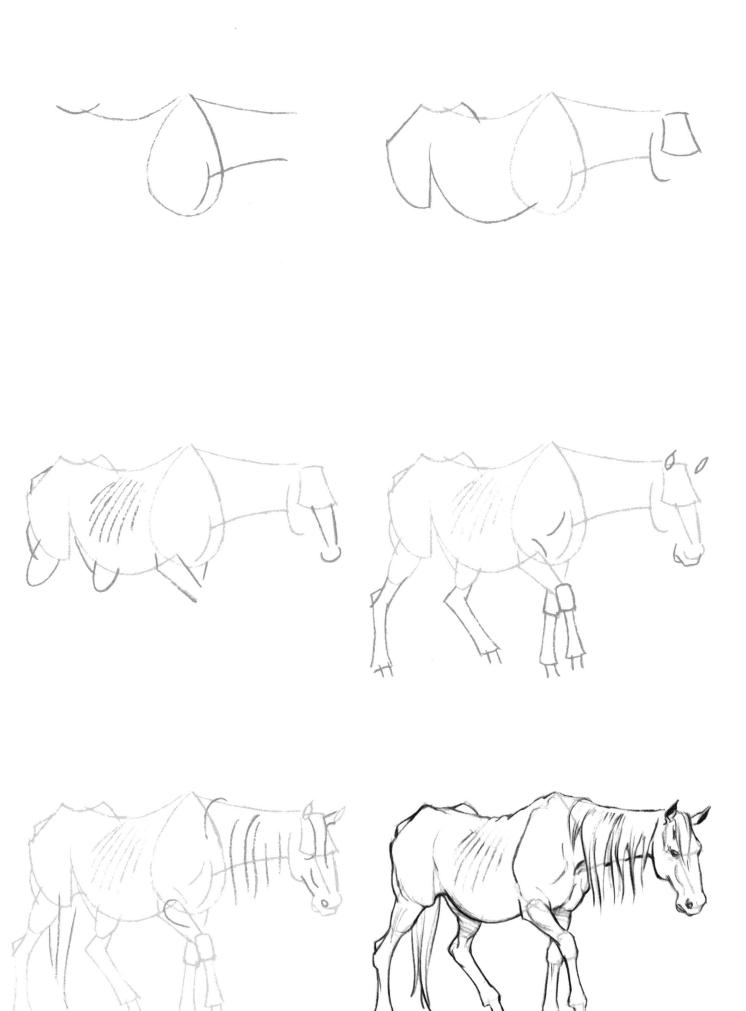

Lee J. Ames has been earning his living as an artist for almost forty years. He began his career working on Walt Disney's *Fantasia* and *Pinocchio*. He has taught at the School of Visual Arts in Manhattan and, more recently, at Dowling College on Long Island. He was, for a time, director of his own advertising agency and illustrator for several magazines. Mr. Ames has illustrated over one hundred books, from preschool picture books to postgraduate texts. When not working, he battles on the tennis court. A native New Yorker, Lee J. Ames lives in Dix Hills, Long Island, with his wife, Jocelyn, their three dogs, and a calico cat.

DRAW 50 FOR HOURS OF FUN!

Using Lee J. Ames's proven, step-by-step method of drawing instruction, you can easily learn to draw animals, monsters, airplanes, cars, sharks, buildings, dinosaurs, famous cartoons, and so much more! Millions of people have learned to draw by using the award-winning "Draw 50" technique. Now you can too!

COLLECT THE ENTIRE DRAW 50 SERIES!

The Draw 50 Series books are available from your local bookstore. You may also order direct (make a copy of this form to order). Titles are paperback, unless otherwise indicated.

ISBN	TITLE	PRICE	QTY	TOTAL
23629-8	Airplanes, Aircraft, and Spacecraft	\$8.95/\$13.95 Can	× =	
49145-X	Aliens	\$8.95/\$13.95 Can	× =	
19519-2	Animals	\$8.95/\$13.95 Can	× =	
90544-X	Animal Toons	\$8.95/\$13.95 Can	× =	
24638-2	Athletes	\$8.95/\$13.95 Can	× =	
26767-3	Beasties and Yugglies and Turnover Uglies and Things That Go Bump in the Night	\$8.95/\$13.95 Can	× =	
47163-7		\$8.95/\$13.95 Can	× =	
	Birds (hardcover)	\$13.95/\$18.95 Can	× =	
	Boats, Ships, Trucks, and Trains	\$8.95/\$13.95 Can	× =	
	Buildings and Other Structures	\$8.95/\$13.95 Can	× =	
	Cars, Trucks, and Motorcycles	\$8.95/\$13.95 Can	× =	
24640-4	,	\$8.95/\$13.95 Can	× =	
	Creepy Crawlies	\$8.95/\$13.95 Can	× =	
	Dinosaurs and Other Prehistoric	ψο. / ο / ψ το. / ο ean	^	
170200	Animals	\$8.95/\$13.95 Can	× =	
23431-7	Dogs	\$8.95/\$13.95 Can	× =	
46985-3	Endangered Animals	\$8.95/\$13.95 Can	× =	
19521-4	Famous Cartoons	\$8.95/\$13.95 Can	× =	
23432-5	Famous Faces	\$8.95/\$13.95 Can	× =	
47150-5	Flowers, Trees, and Other Plants	\$8.95/\$13.95 Can	× =	
26770-3	Holiday Decorations	\$8.95/\$13.95 Can	× =	
17642-2	Horses	\$8.95/\$13.95 Can	× =	
17639-2	Monsters	\$8.95/\$13.95 Can	× =	
41194-4	People	\$8.95/\$13.95 Can	× =	
47162-9	People of the Bible	\$8.95/\$13.95 Can	× =	
47005-3	People of the Bible (hardcover)	\$13.95/\$19.95 Can	× =	
26768-1	Sharks, Whales, and Other Sea			
	Creatures	\$8.95/\$13.95 Can	× =	
14154-8		\$8.95/\$13.95 Can	× =	
	Shipping and handling	(add \$2.50 per order)× =	
		TOTAL		

Please send me the title(s)	I have indicated above. I	l am enclosina \$
-----------------------------	---------------------------	-------------------

Send check or money order in U.S. funds only (no C.O.D.s or cash, please). Make check payable to Random House, Inc. Allow 4–6 weeks for delivery. Prices and availability subject to change without notice.

Name:	
Address:	Apt. #
City:	State: Zip:

Random House, Inc. Customer Service 400 Hahn Rd. Westminster, MD 21157